EDINBURGH REFLECTIONS

Jack Gillon

AMBERLEY

First published 2024

Amberley Publishing
The Hill, Stroud, Gloucestershire, GL5 4EP
www.amberley-books.com

Copyright © Jack Gillon, 2024

The right of Jack Gillon to be identified as the Author
of this work has been asserted in accordance with the
Copyrights, Designs and Patents Act 1988.

ISBN 978 1 3981 1773 0 (print)
ISBN 978 1 3981 1774 7 (ebook)

British Library Cataloguing in Publication Data.
A catalogue record for this book is available from the
British Library.

Typesetting by SJmagic DESIGN SERVICES, India.
Printed in Great Britain.

Introduction

Edinburgh, Scotland's capital city, has a dramatic cityscape and its wealth of historic streets and buildings make up the UNESCO Old and New Towns World Heritage Site. The following pages include several landmark buildings but concentrate attention on areas which have been subject to significant change, particularly those which had their inception following the radical proposals for redevelopment and new roads which were included in the Civic Survey and Plan for the City and Royal Burgh of Edinburgh (the Abercrombie Plan), published on 1 January 1949. The proposals in the plan were widely criticised and were described by one correspondent to the *Scotsman* as a 'sacrilegious outrage'. Most were ultimately abandoned due to the innate conservative nature of the city, articulate pressure groups, the outstanding heritage value of the city centre and the topography which made many of the road proposals impractical. However, several schemes did progress and left their mark on the city.

Princes Street

Princes Street was originally built as a uniform residential development of three-storey terraces. By the latter part of the nineteenth century, in order to accommodate the increasing commercial nature of the street, the complete replacement or radical adaptation of the original small-scale Georgian domestic buildings was underway. These new buildings tended to be of a larger scale and more ornate than their predecessors.

The Abercrombie Plan criticised the laissez-faire development of the Victorian and Edwardian periods on Princes Street that had produced a lack of architectural cohesion. The plan proposed the complete redevelopment of the street, within an overall framework for height and massing to restore visual cohesion. This theme was taken up by the Princes Street Panel's Report in 1967, which recommended that Princes Street should be comprehensively redeveloped with a unified design incorporating an elevated pedestrian walkway with the intention of creating a continuous high-level second street. Several sites were redeveloped in line with the panel's formula. However, the loss of buildings of architectural merit resulted in the panel's recommendations being abandoned in 1982. The reaction against Victorian architecture, and the sad loss of many fine buildings of the period, was symptomatic of the 1950s and 1960s, a time when progress and Modernism were being widely adopted.

St James Square Area

Parts of Edinburgh were significantly changed in the 1960s to clear areas that were considered slums and provide improved housing. The Abercrombie Plan proposed the demolition of St James Square to create a new theatre and concert hall. St James Square dated from the eighteenth century and had been designed by James Craig, the originator of the plan for the first New Town. The plans for the theatre and concert hall were later abandoned. However, the Square, the Leith Street frontage with its distinctive first-floor terrace, and neighbouring streets did not survive the comprehensive redevelopment of the 1960s.

Dumbiedykes

The Abercrombie Plan identified that a quarter of a million people, half the then population of Edinburgh, were living in outdated properties containing inadequate sanitary facilities. The collapse of what was known as the 'Penny Tenement' in Dumbiedykes' Beaumont Place on 21 November 1958 focused attention on Edinburgh's slums. In December 1959, Edinburgh councillors made a tour of inspection of the St Leonard's area to view the problems first-hand. Two extensive clearance areas around Carnegie Street were declared shortly afterwards and a hundred families were immediately moved from dangerous homes and rehoused – the beginning of a major slum-clearance drive. In the early 1960s, 1,030 houses were demolished in the St Leonard's area and an estimated 1,977 people displaced. Slum clearance was also the impetus for major redevelopment in Newhaven, Leith and parts of the Old Town.

George Square

The original townhouses in George Square were built in 1766 as a new architecturally unified development of 'superior style' terraced houses around a central square. The University of Edinburgh had promoted plans to redevelop George Square and a wider part of the South Side as early as 1945. The Abercrombie Plan considered that it was not essential to retain the buildings around George Square and believed that they did not deserve 'pride of place in Edinburgh's heritage'. Fierce debate about the proposals took place throughout the 1950s. Planning permission was granted for demolition in 1956 but mounting opposition to the scheme resulted in a public inquiry in 1959. The Historic Buildings Council then indicated that they considered George Square interesting but not comparable to the quality of Charlotte Square and the technical advice was that they were too derelict for reuse. The fate of the historic buildings in the area was sealed and early in the 1960s the redevelopment proceeded. In the face of a public outcry, Modernist blocks replaced many of the original buildings on George Square and the Bristo area.

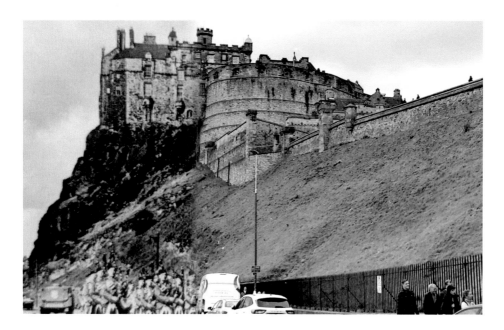

Edinburgh Castle from Johnston Terrace
Dramatically situated on its precipitous crag, the turreted and battlemented castle towers over the city centre and dominates the skyline. The castle rock was first settled in prehistoric times and is first mentioned as *Dineidin* in a sixth-century Welsh poem. A royal castle was present from at least the tenth century. The castle has had a turbulent history and has performed many different roles over the centuries. It is dominated on its east side by the massive retaining wall of the Half Moon Battery, built in 1574, and by the sixteenth-century King's Lodging, which housed the royal apartments. The massive Georgian New Barracks, completed in 1799, rise over the west side of the crag.

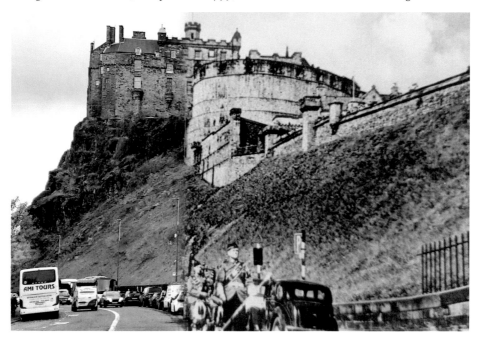

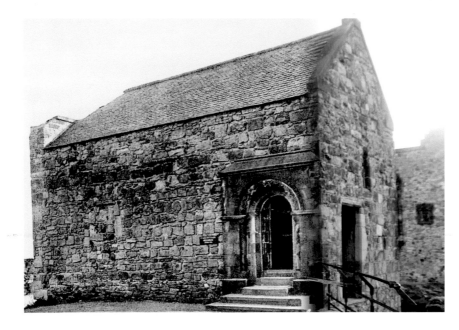

St Margaret's Chapel, Edinburgh Castle

The diminutive ancient Romanesque chapel dedicated to St Margaret stands at the highest point of the castle and is the oldest surviving building in the city. It dates from the first half of the twelfth century. Queen Margaret (1045–93) was canonised by Pope Innocent IV in 1250 for her charitable work and religious fidelity. The chapel was saved on the orders of King Robert the Bruce when the castle was demolished in 1314 to prevent it from being taken by English forces. From the sixteenth century, following the Reformation, the chapel was used as a munitions store. The significance of the building was rediscovered in 1845 and it was partly restored in 1853. Another restoration of the building was carried out in 1993 to commemorate the 900th anniversary of the death of St Margaret.

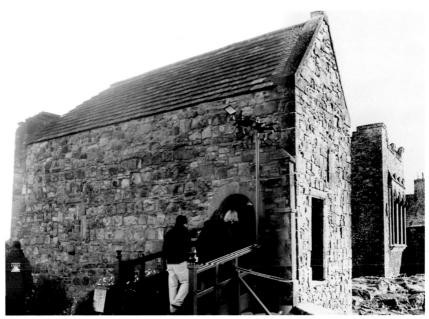

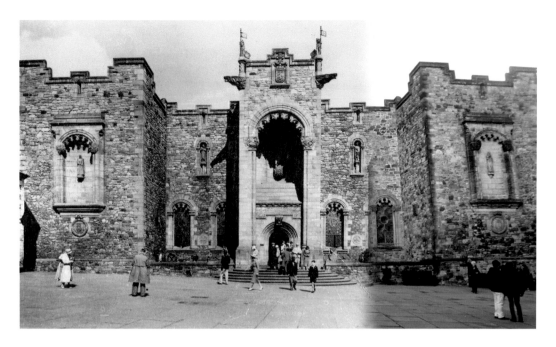

Scottish National War Memorial, Edinburgh Castle

Few families in Scotland were not touched in some way by the impact of the First World War and the Scottish National War Memorial commemorates the sacrifices of nearly 150,000 Scots in the conflict. It was designed by Sir Robert Lorimer (1864–1929) and stands on Crown Square at the summit of the castle rock. The memorial was opened by the Prince of Wales on 14 July 1927. At the time of its construction, it was believed by many that the memorial would be a shrine to the 'war to end all wars', and it is sad to reflect that it now also commemorates the more than 50,000 Scottish fatalities of the Second World War and conflicts since then.

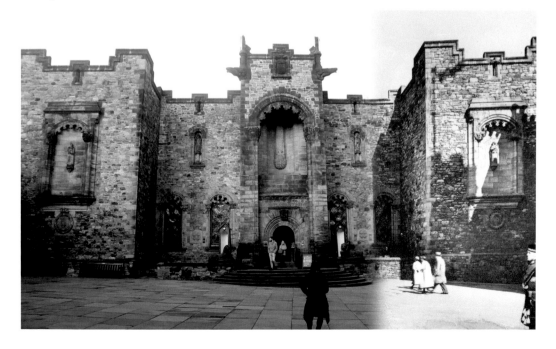

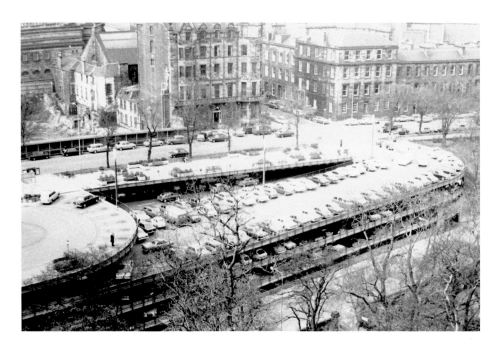

View over Castle Terrace from Castle

The gap site on Castle Terrace in the older image was the site of the Synod Hall. It originally opened in 1875 as the West End Theatre and was described as 'one of the most elegant and complete in the whole of the kingdom'. However, it was a financial failure and, in 1877, it was converted for use by the Synod of the United Presbyterian Church. In 1906, the Poole family were using the building to show myrioramas (moving panoramas) and by the mid-1920s it was operating as a cinema, which closed in 1965. The building was demolished shortly after to make way for an opera house that was never built. The site is now occupied by an office block – Saltire Court. The Castle Terrace multi-storey car park in the foreground of the images was completed by 1966.

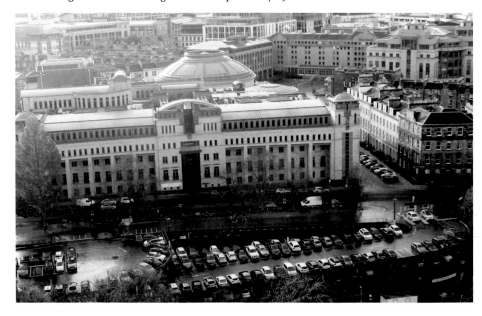

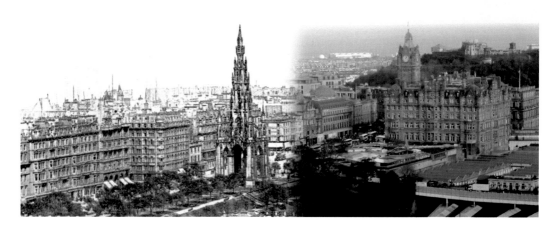

View over Princes Street from Castle
The Scott Monument, the North British (Balmoral Hotel) and the monuments on Calton Hill are fixtures in both images. Several buildings on Princes Street have been replaced and the old Waverley Market has been redeveloped. The ribbon hotel in the St James Quarter and the big wheel for Edinburgh's Christmas celebrations are prominent features in the more recent image.

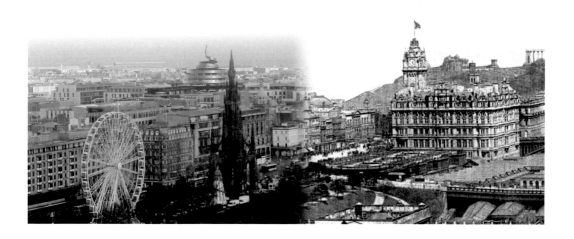

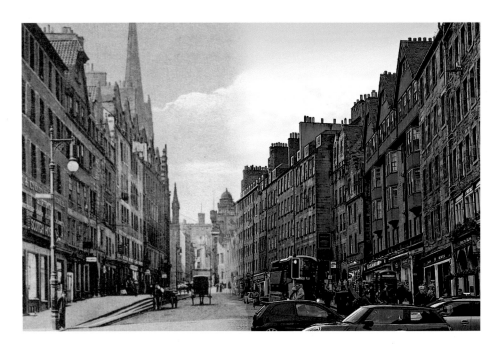

Lawnmarket

The Royal Mile is a sequence of five historic streets (Castlehill, Lawnmarket, High Street, Canongate, and Abbey Strand). In 1477, James III granted a charter for a *landmercatt* in Edinburgh for merchants from outside the town. By 1690, the upper part of the High Street was primarily associated with the *landmercatt*. By the mid-eighteenth century the *landmercatt was* being recorded as the Lawnmarket. Gladstone's Land on the Lawnmarket, with its arcaded ground floor, curved stone forestair and leaded glazing, is one of the finest and most original surviving examples of an early seventeenth-century tenement building in the Old Town.

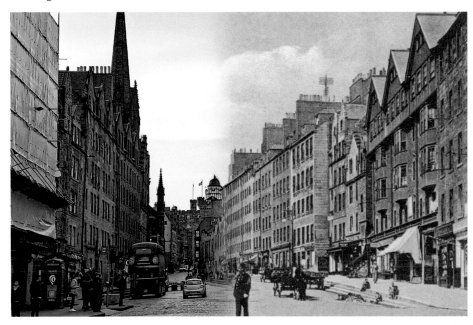

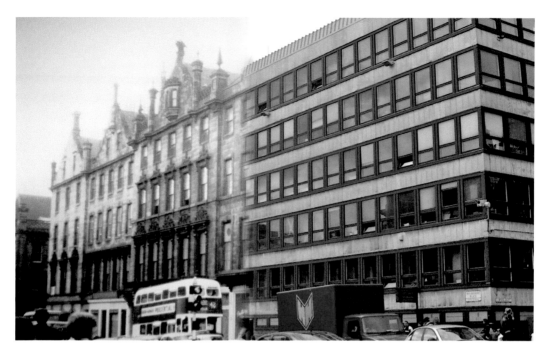

George IV Bridge

The King George IV Bridge was designed by Thomas Hamilton as a south approach to the Old Town as part of the City Improvement Act of 1827 and opened in 1834. In 1968, the original buildings on George IV Bridge, between Victoria Street and the Lawnmarket, were replaced by a Brutalist office block designed by Robert Matthew Johnson-Marshall & Partners. The building was the headquarters of Lothian Region Council.

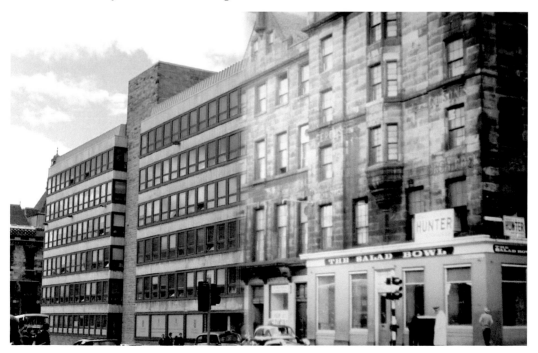

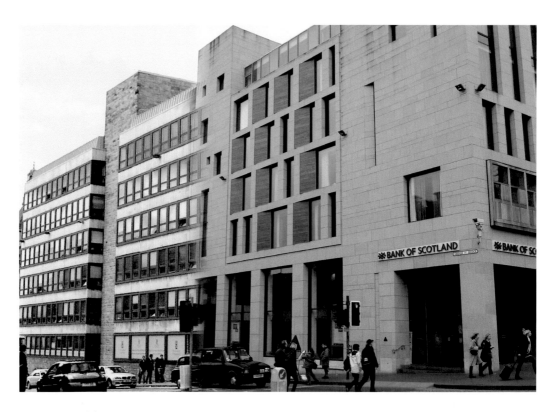

George IV Bridge
The 1968 office block on George IV Bridge was replaced by a new mixed-use hotel development by 2009.

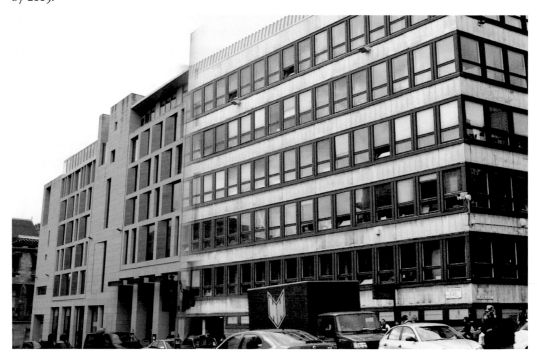

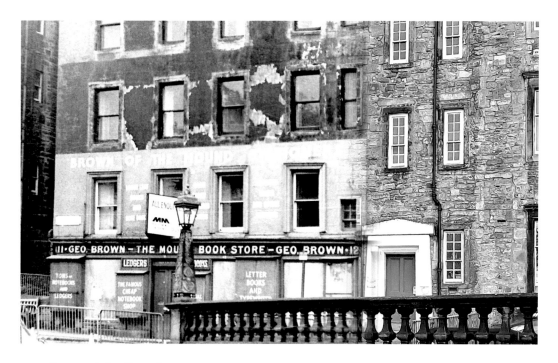

Brown of the Mound

George Brown opened the stationery business on the Mound in February 1879. With its copious signage, the shop was a prominent feature on the Mound until its closure in the 1970s. The upper floors were converted into apartments and the ground floor has since been a pub trading under several different names.

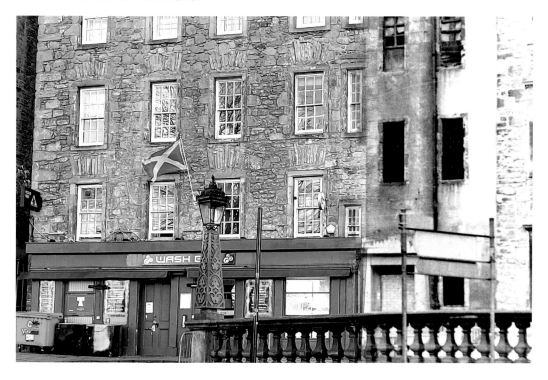

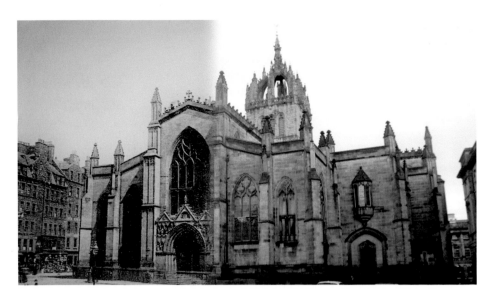

St Giles (High) Kirk, High Street and Parliament Square

St Giles, the High Kirk of Edinburgh, has its origins in the mid-twelfth century. It is named after a seventh-century hermit, the patron saint of cripples, beggars, lepers, and blacksmiths. It was rebuilt after it was burned down in 1385, during the sacking of Edinburgh, and the core of the building dates from the fourteenth century. The landmark crown spire was added around 1495 and rebuilt in 1646. It was converted for Presbyterian worship during the Reformation and John Knox served as minister from 1559 until his death in 1572. The church was subdivided for the use of four different congregations in the seventeenth century and fell into a state of disrepair. In 1829–33, the frontage was rebuilt in an overenthusiastic restoration by William Burn. Much of its medieval character was lost at this time – fortunately funds ran out before the work extended to the medieval masonry of the crown steeple. The internal partitions were not fully removed, and a single space created, until a further restoration scheme in 1881–3.

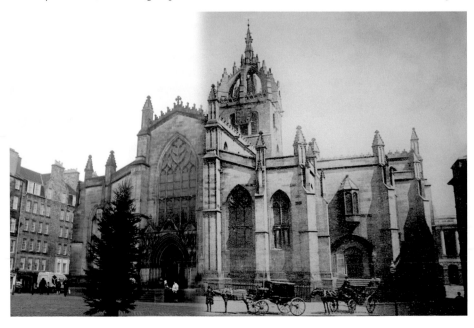

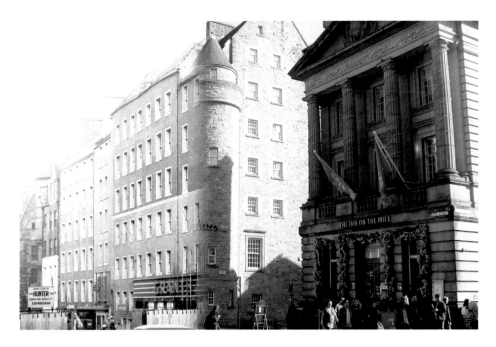

Grants, High Street

Grants (James Grant & Co. Ltd) at 80–86 High Street billed themselves as Scotland's National Furnishers. The building which Grants occupied on the High Street was demolished in around 1970 due to subsidence and the site lay empty as an infamous gap site until it was redeveloped as a hotel (originally the Scandic Crown), which opened in 1990. The new building was designed in a modern interpretation of the Baronial style. A plaque on the side of the main entrance is inscribed: *Al This Wark Was Begun Dancon on 10-January-1989 an Endit Be Them on 31-March-1990* and another plaque at the foot of the tower is dated AD 1989. These remove any doubt about the date of the building.

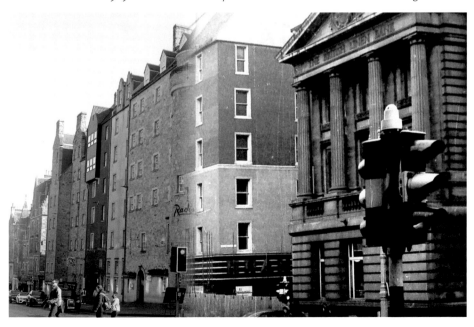

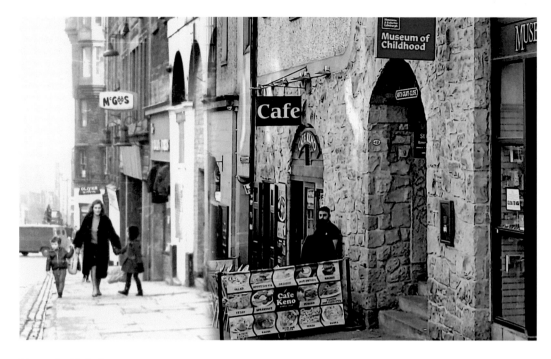

Mcgoo's, High Street

Views down the High Street featuring a sign for McGoo's nightclub in the older image. McGoo's occupied the former Palace Picture House and was a favourite venue for mid-1960s Mods. The club hosted many local bands and bigger names such as The Kinks, The Spencer Davis Group, Small Faces and The Who. Only the façade of the old cinema building remains. The Museum of Childhood opened in 1955 and was the first museum in the world to specialise in the history of childhood.

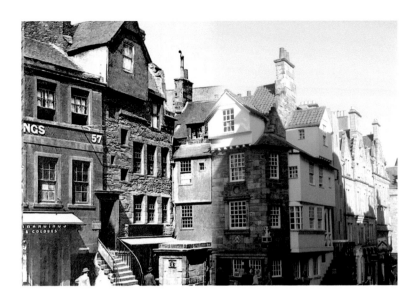

John Knox House, High Street

John Knox's House dates mainly from sixteenth century and is the earliest surviving tenement in Edinburgh. It was built by James Mosman, goldsmith to Mary, Queen of Scots, and bears his initials and those of his wife, Mariota Arres. The inscription '*Lufe God abufe al and yi nyghbour as yi self*' is inscribed above the entrance door and there is a carved figure of Moses above a sundial on the corner. Mosman was executed for treason in 1573. (Queen Elizabeth took exception to him pawning the crown jewels and he was hanged, drawn and quartered at the Mercat Cross.) The question whether John Knox ever lived in the house has been hotly contested, although there is a tradition that he was resident shortly before his death on 24 November 1572. The house was in a dilapidated condition during the 1840s and, in 1849, was considered for demolition. Its retention and preservation had much to do with the association with Knox. The building was restored in the mid-nineteenth century and converted into a museum. It now forms part of the Netherbow Arts Centre.

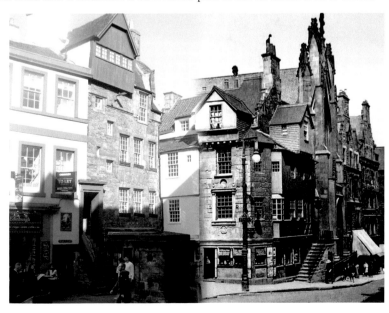

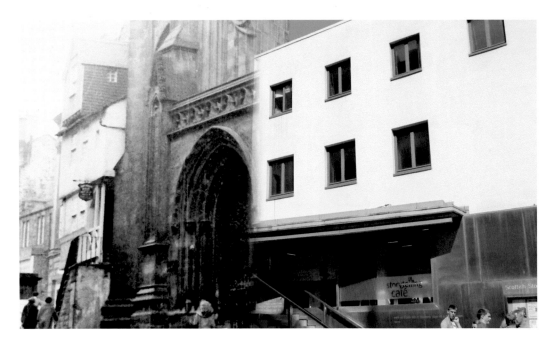

Moray-Knox Church, High Street

In the late 1960s, the Moray-Knox Church was replaced by the Netherbow Arts Centre, which was transformed into the Scottish Storytelling Centre in 2006. The Netherbow Bell, which was sounded as prisoners went to their execution at the Netherbow Port, and the plaque from the Port were incorporated into the Netherbow Centre.

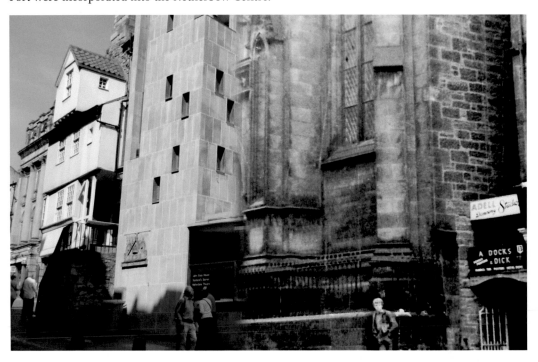

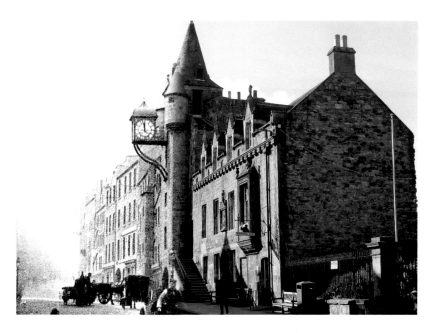

Canongate Tolbooth

The Canongate Tolbooth dates from 1591 and is a rare survivor of sixteenth-century municipal architecture. It was the administrative hub of the Canongate when it was an independent burgh. It overflows with architectural detailing – turrets and gun loops to the street, a forestair in the angle of the tower and an oversized scrolled wrought-iron clock, which is a later addition of 1820. (It was repaired in 1884 and this date is inscribed on the clock.) It is embellished by a carved stone panel at first-floor level with the arms of the Canongate: a stag's head and Latin inscription 'SIC ITUR AD ASTRA 1128' (thus is the way to the stars). In 1879, the City Architect, Robert Morham, restored and remodelled the exterior. It now functions as the People's Story Museum.

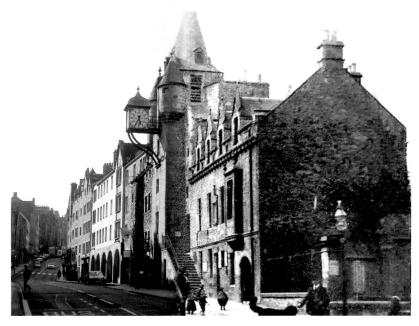

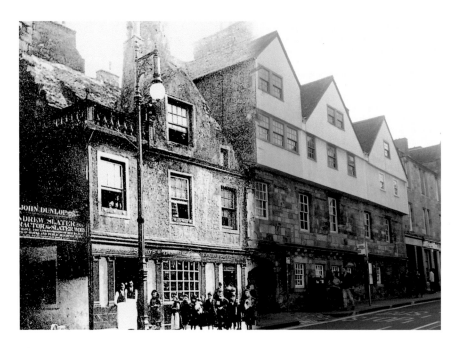

Huntly House, Canongate

Huntly House was originally three separate, mainly early sixteenth-century, tenements, which were amalgamated in 1579 to form a single expansive dwelling. From 1647, the building was owned and extended by the Incorporation of Hammermen. The property has only a passing association with the Gordons of Huntly, but the name seems to have stuck. The building was restored as a museum for the local authority by Sir Frank Mears in 1927. It is now the Museum of Edinburgh. It is known as the Speaking House from the gilded Latin inscriptions on the frontage.

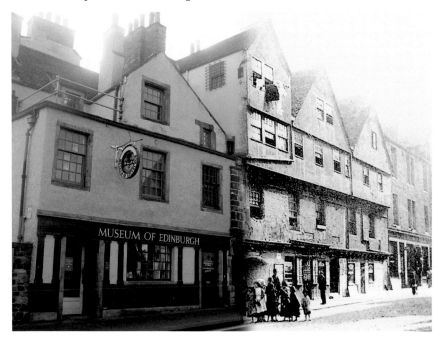

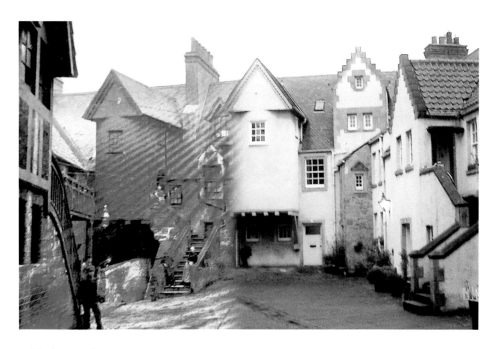

Whitehorse Close

Whitehorse Close with its idiosyncratic mix of crowstepped gables, harling, projecting bays, forestairs and pantiled roofs is one of the most picturesque closes in the Old Town. It has its origins in the early seventeenth century when it was built with houses, stables and the White Horse Inn on the site of the Holyrood Palace Royal Mews. The inn was the terminus of one of the first regular stagecoaches to London. The name of the close is said to derive from a favourite horse of Mary, Queen of Scots. In 1889, the buildings were converted into fifteen houses. By the 1960s, they needed repair and upgrading. Extensive restoration and reconstruction work was carried out in 1964–5. It is one of the most charming parts of the Royal Mile.

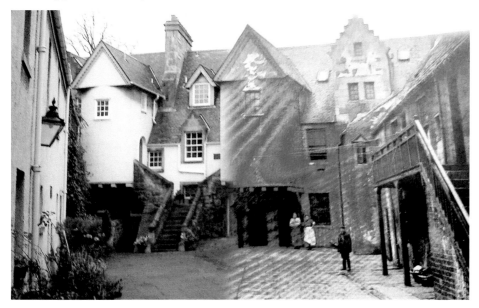

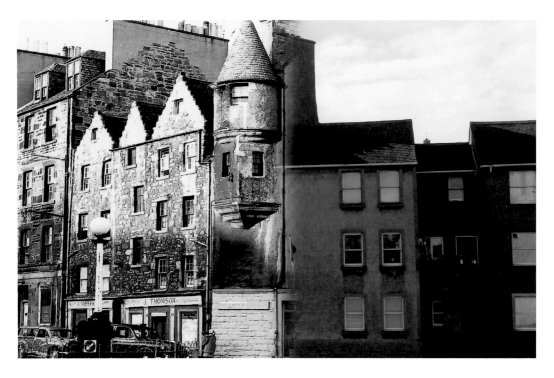

Canongate

The four-storey building with the three crowstepped wallhead gables in the images is Russell House, which dates from 1690. It was restored in 1976. The adjoining buildings in the earlier image were lost to demolition in the early 1970s and were replaced by a new housing association development. The building on the right of the earlier image was part of an infill development by Sir Patrick Geddes in the 1890s to provide improved standards of housing in the area.

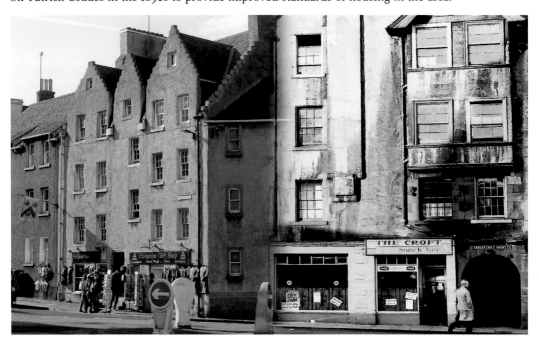

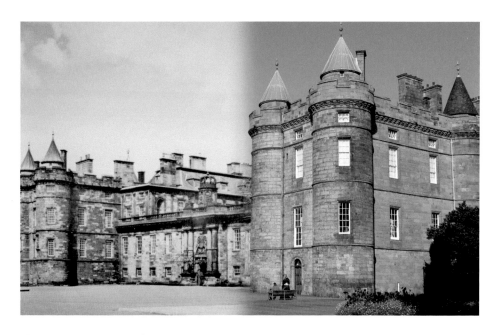

The Palace of Holyroodhouse

The Palace of Holyroodhouse developed from a royal guest house which was part of Holyrood Abbey. It was transformed into a royal palace at the start of the sixteenth century during the reign of James IV. Additions were made between 1528 and 1536 by his son King James V (1512–42), who is said to have 'built a fair palace, with three towers'. The palace was damaged during English invasions, first by the Earl of Hertford in 1544, and again in 1650 during its occupation by Cromwell's troops. The present palace largely dates from a reconstruction in 1671, when it was rebuilt in the French Chateau style by architect Sir William Bruce (1630–1710) and builder Robert Mylne (1633–1710) for the Restoration of Charles II. The palace is the formal Scottish residence of the Queen during State visits to Edinburgh.

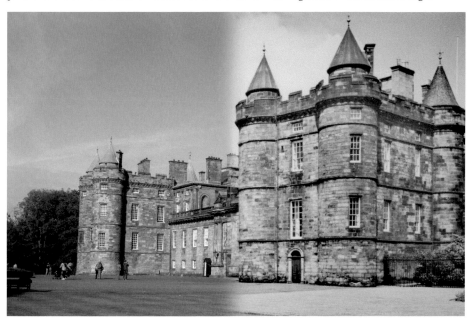

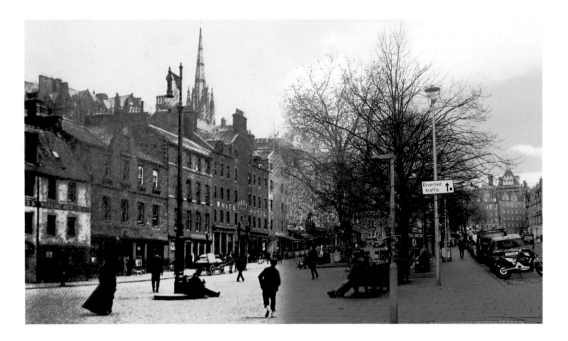

The Grassmarket

The Grassmarket is the largest open space in the Old Town with a spectacular prospect of the southern cliffs of the castle rock. The Grassmarket was the main approach from the west to the Old Town. Before Victoria Street was constructed, in the nineteenth century, the route followed the West Bow, which rose steeply up to the High Street. The first written record of a market in the Grassmarket dates from 1477, and its long rectangular shape is still immediately recognisable as a marketplace. The principal commodity traded in the area was livestock, the grazing of which accounts for the name. For centuries, until 1758, one of Edinburgh's public gallows stood in the Grassmarket and the area served as the site for public executions. In 2010, a new public realm design pedestrianised the north side of the Grassmarket.

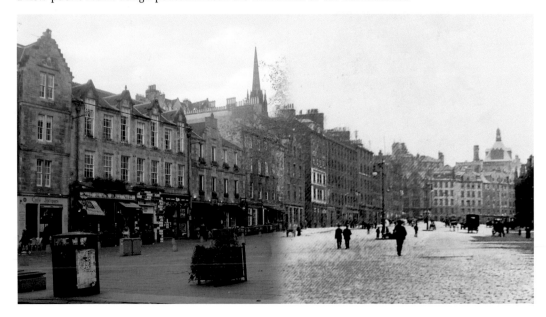

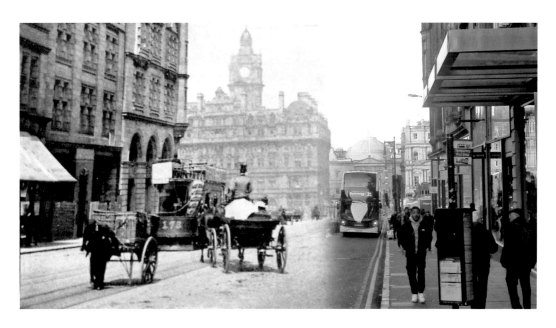

North Bridge

The foundation stone of the original North Bridge was laid in 1763; however, its completion was delayed by financial problems, and it opened in 1769, only to partially collapse, killing five people. It was not until 1772 that it became fully operational. The bridge spanning the deep valley to the north of the Old Town was an essential component of the plans for the northward expansion of Edinburgh and the creation of the New Town. The original bridge was replaced by the present structure, which opened in 1897. At the time of writing, a major repair project was underway on the bridge.

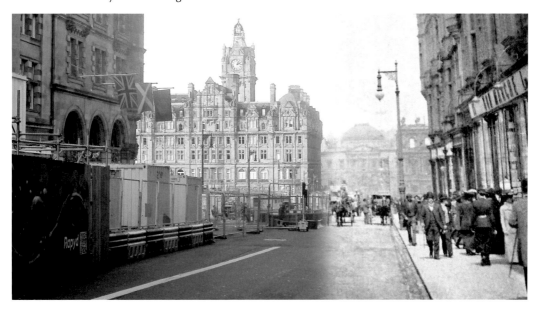

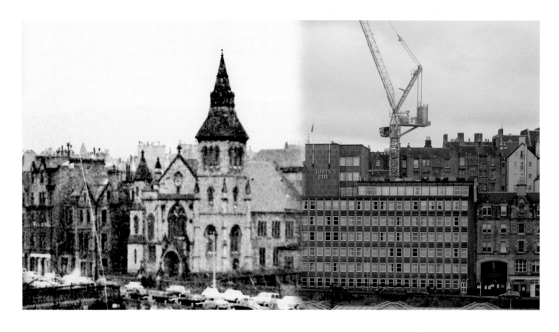

View to Market Street and Jeffrey Street

Mary of Guelders (1433–63) founded Trinity College Church as a memorial to her husband, King James II, who was killed at the siege of Roxburgh in 1460. The church was located below Calton Hill and, in 1848, it was taken down stone by stone to make way for Waverley station. The stones were numbered and stored on Calton Hill with the intention of rebuilding the church. By 1872, when plans got underway to reconstruct the church, a large quantity of the original masonry had disappeared. The stones that remained were used to construct Trinity Apse on Chalmer's Close and a new extension fronting Jeffrey Street was also built. The older image shows the last days of the Victorian addition which, along with adjoining buildings, was demolished in 1964 to make way for a modern office building, which is now Jury's Inn. The very handy footbridge, which ran across Waverley station from Jeffrey Street to Calton Road, can also be seen in the older image. It was removed in 1958.

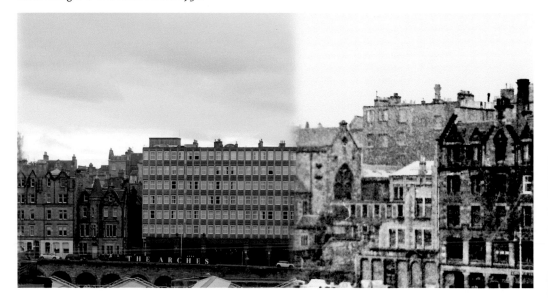

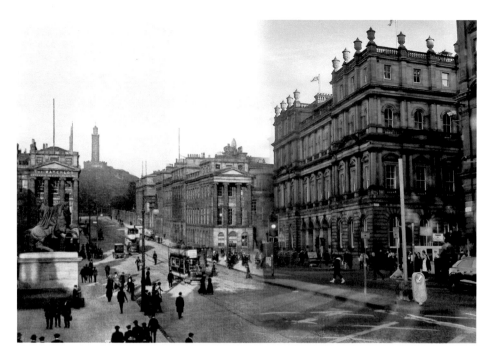

Waterloo Place

Waterloo Place traverses the Regent Bridge, which was officially opened on 18 August 1819. The bridge provided a convenient new access road over the Low Calton valley linking Princes Street to Calton Hill. The street name commemorates the Battle of Waterloo. The building at the corner of North Bridge and Princes Street was constructed between 1861 and 1865 as the General Post Office on the site of the old Theatre Royal. In 2000, the original interior of the building was removed and replaced with modern office space.

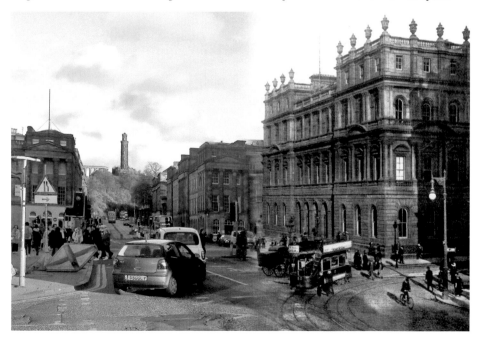

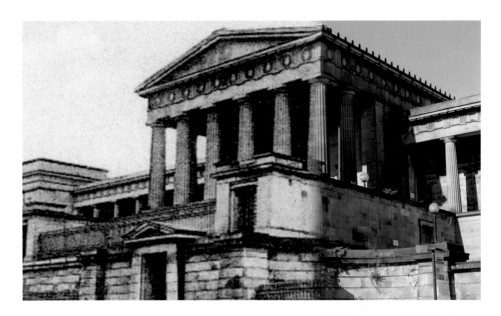

Royal High School

The Royal High School is recognised as a masterpiece of Greek Revival architecture. It was originally founded in 1128 (making it the oldest school in Scotland). From the sixteenth century, the school was located at High School Yards. In 1829, the new building, designed by Thomas Hamilton, was completed. The construction involved removing a large section of Calton Hill to create a level site. King George IV contributed £500 towards the costs and the school gained the 'Royal' appellation. The school moved to Barnton in 1968 and the main hall in the building was converted into a debating chamber for the Scottish Assembly, prior to the 1979 devolution referendum which failed to provide enough support for a devolved assembly. Following the devolution referendum of 1997, the proposal to use the building for the Scottish Parliament was abandoned in favour of a new building in the Old Town. There have been various proposals for its reuse.

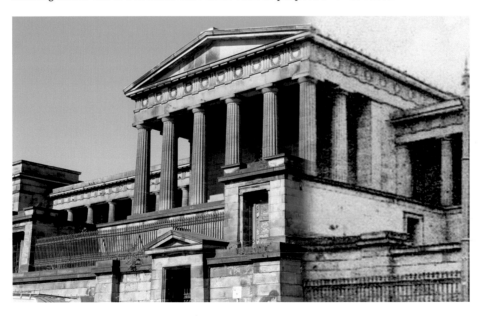

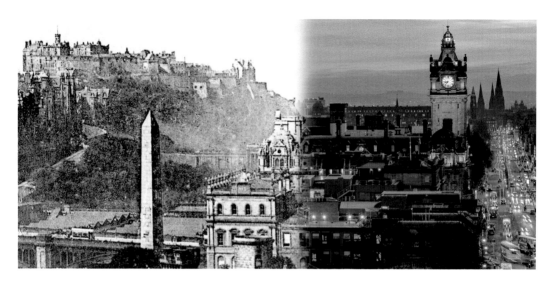

View from Calton Hill

The dramatic view over Edinburgh from Calton Hill encompasses Princes Street, North Bridge, and Edinburgh Castle. The large obelisk feature in the images is the Political Martyrs' Monument in the Calton Burial Ground. The monument commemorates the five Chartist martyrs who campaigned for electoral form in the eighteenth century. In 1793, they were found guilty of treason and were sentenced to transportation to the penal colony at Botany Bay. They were pardoned in 1838 and funds for the monument were raised by public subscription. The foundation stone was laid on 21 August 1844, with 3,000 people in attendance.

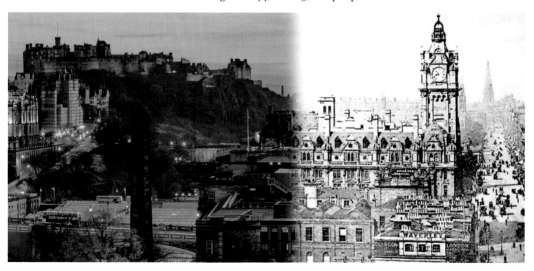

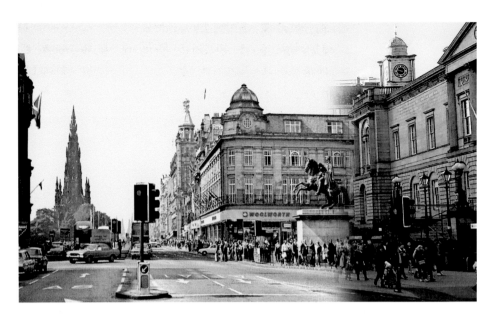

East End of Princes Street

The Woolworths store in the older image opened in March 1926. The store was intended to be the flagship Woolworths in Scotland and, with its prime location on Princes Street, it soon became an Edinburgh landmark. In 1956, the store was extended to take in the former Palace Picture House premises immediately to the west. The store survived until 1984, when the company's new owners decided to close several larger premises around the UK. The bronze statue of the Duke of Wellington (1769–1852) was the work Sir John Steell (the Iron Duke in bronze by Steell). It was unveiled on 18 June 1852, the anniversary of the Battle of Waterloo, by the Duke of Buccleuch. It depicts Wellington in a heroic pose mounted on his war horse, Copenhagen, with his right arm raised. The weight of the statue is cleverly supported on the hind legs and tail of the horse.

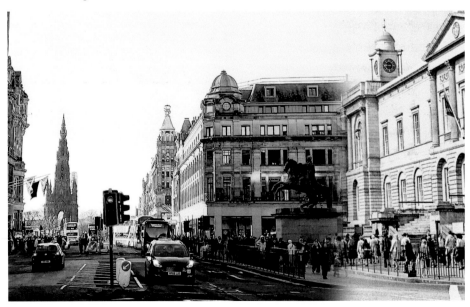

General Register House, Princes Street

In 1752, an Act provided the authority to construct a building to accommodate the Public Records of Scotland. In 1765, representations to the government resulted in a grant of £12,000 for the construction of a 'proper repository'. In 1769, the Town Council supplied the ground opposite the north end of the newly completed North Bridge and Robert Adam, along with his brother James, were commissioned to design the new building. Work began in 1773, however, the structure was costly, and work was suspended at the end of 1778 with the roofless shell of the building standing empty as 'the most expensive pigeon house in Europe'. In 1785, additional funds allowed work to recommence, and the building was ready for occupation by the end of 1788. Register House was the first purpose-built record office in Britain and is one of the oldest archive buildings still in continuous use in the world.

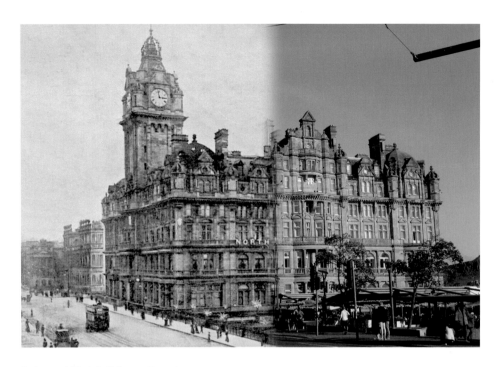

Balmoral Hotel, Princes Street

The massive Balmoral Hotel was opened in 1902 as the North British Railway Hotel to cater for the increased number of travellers arriving by train and it is a major landmark at the east end of Princes Street. The clock on the 58-metre-high tower of the hotel is kept three minutes fast to give rail passengers an incentive to catch their trains. (It is reset to the correct time for Hogmanay.) It became the Balmoral in 1991 after extensive renovation work, but many in Edinburgh still refer to it as the North British or NB.

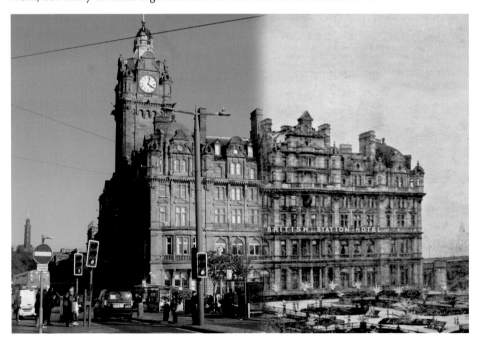

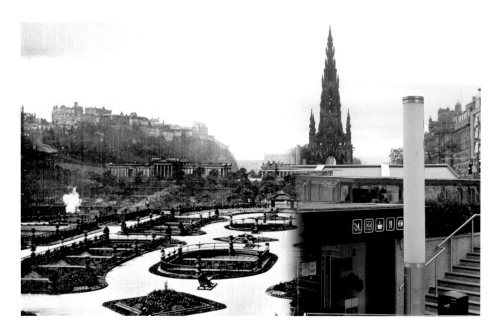

Waverley Market

Located within a slice of the wide gorge between Princes Street and Waverley station, the Waverley Market was once the city's premier vegetable and fruit market. Construction on the building began in 1874. The new building incorporated a large U-plan hall with an elegant, street-level roof garden which preserved the vistas of the Old Town. The Waverley Market later became synonymous with events such as the Ideal Home exhibition, flower shows, dog shows, car shows, circuses, and carnivals. By the early 1970s, the fortunes of the once grand Victorian arcade were in sharp decline and the structure was deemed unsafe. In 1974, a century after work began to build it, the Waverley Market's demolition was underway, and it was replaced by a new shopping centre.

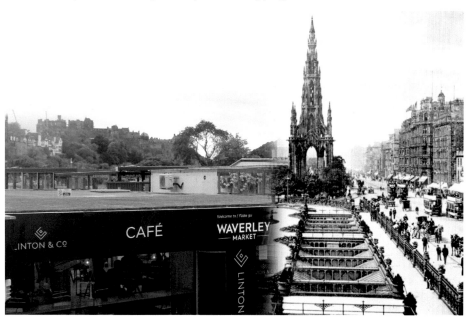

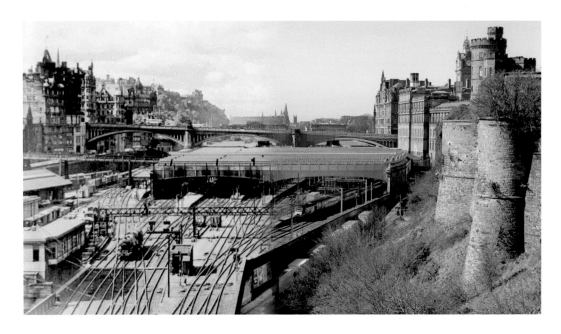

Waverley Station

In the mid-1830s, there were proposals for a railway line running through Princes Street Gardens to a new station at North Bridge. This was opposed by residents of Princes Street, who had been involved in the expense of draining the Nor' Loch and creating the gardens. In 1842, the Edinburgh and Glasgow Railway opened Haymarket station and pressure continued for a new terminus at North Bridge. In 1844, agreement was finally reached for a track, in a cutting flanked by high retaining walls, through the gardens. Three railway companies had stations near one another in the valley at the east end of Princes Street and the name Waverley – from Sir Walter Scott's *Waverley* novels – was used as the collective name for the three stations from around 1854. In 1868, the North British Railway Company acquired all three stations and built a new station on the site.

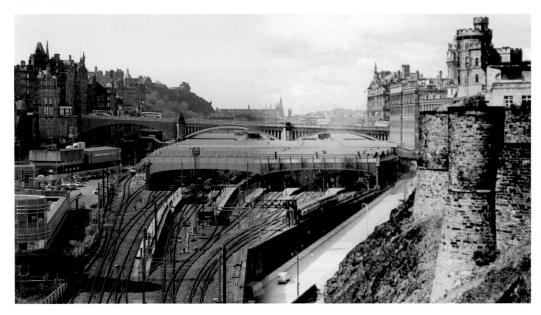

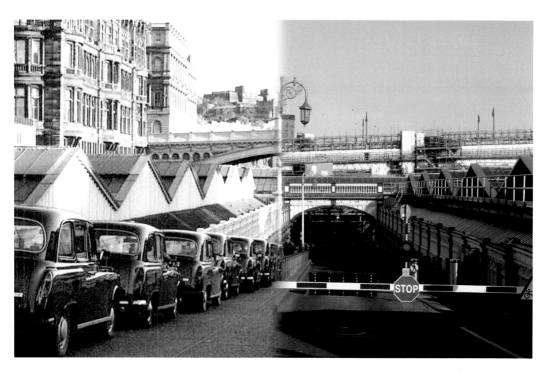

Waverley Station

Taxis are shown conveniently queuing for customers on the down ramp at Waverley station in the older image. In 2014, taxis were banned from the taxi ranks within the station.

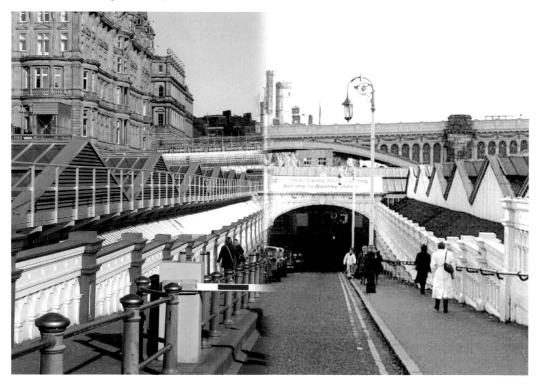

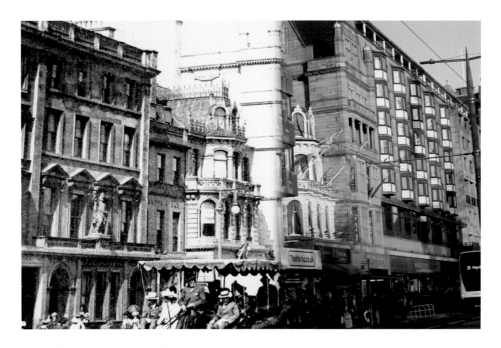

North British and Mercantile, Princes Street

The ornate building to the left of the older image was the headquarters of the North British and Mercantile Insurance Company. The company was established in Edinburgh in 1809 and moved into the new building on Princes Street in the early 1900s. In 1959, the North British and Mercantile amalgamated with Commercial Union and the Princes Street building was declared surplus to requirements. In 1964, British Home Stores purchased the building, and it was redeveloped in 1965. The new building was the first to fully adopt the recommendations of the Princes Street Panel.

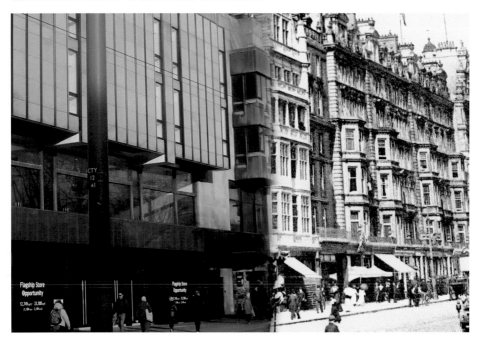

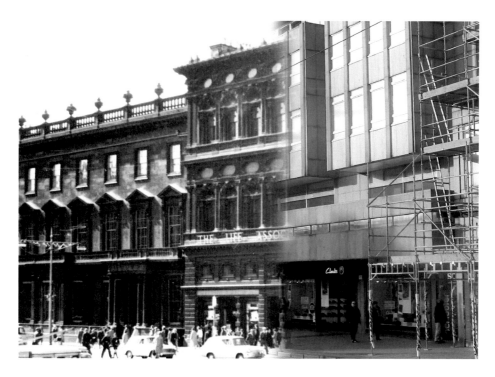

Life Association and New Club, Princes Street

The Life Association of Scotland building and the adjoining New Club in the older image were demolished in 1967 and replaced by new developments, which followed the Princes Street Panel's recommendations. The Life Association building dated from 1858 and was designed by David Rhind and Sir Charles Barry, the architect of the Houses of Parliament. It was one of the best Venetian High Renaissance buildings in Britain. The adjoining New Club dated from 1837.

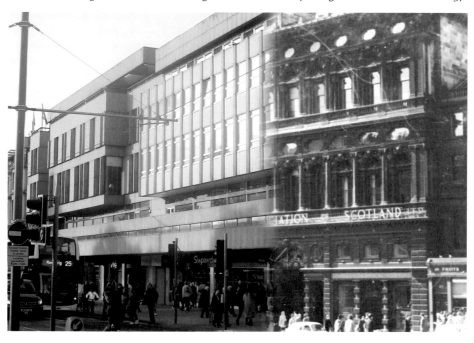

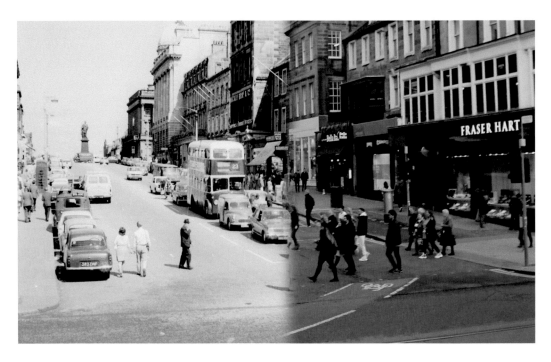

Hanover Street

These views are looking towards Hanover Street from Princes Street. The Brown Derby Restaurant, the Three Tuns, the Allegro Restaurant, Richard Shops, Crawford's, and Hector Powe are prominent commercial premises in the older image. A policeman in a white coat is also on point duty and a Jenner's van is waiting at the junction.

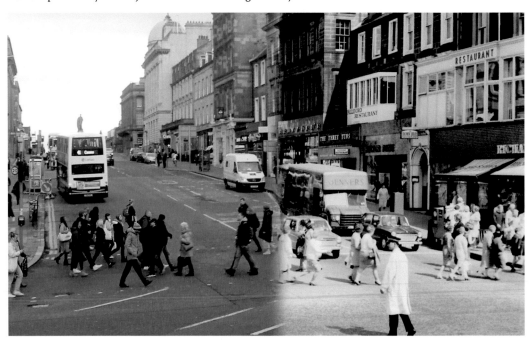

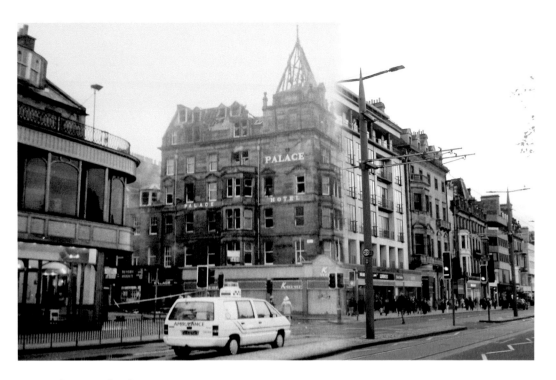

Palace Hotel, Princes Street

The Palace Hotel on the corner of Princes Street and Castle Street, which first opened for business in 1889, was badly damaged by a fire on the evening of 9 June 1991. The fire was started by a group of youths that had broken into the building, which was unoccupied at the time. The building was demolished shortly after and replaced with a modern structure in 1995.

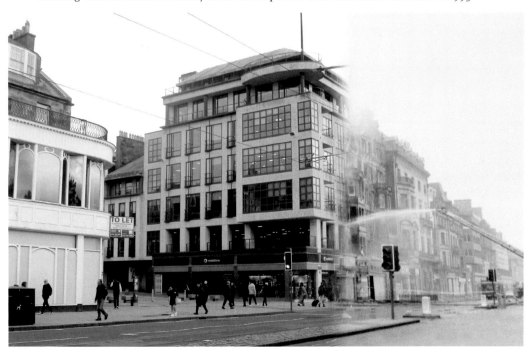

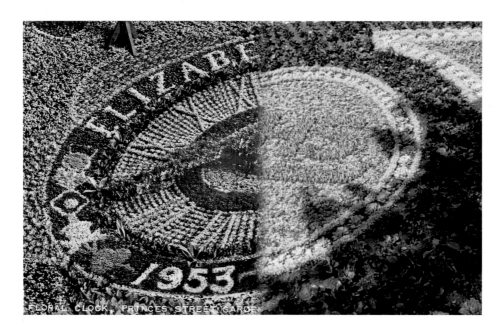

The Floral Clock, West Princes Street Gardens

Edinburgh's floral clock is a memorable feature of West Princes Street Gardens. The floral clock was originally planted in 1903 and was the first in the world. It was the idea of James McHattie, City Superintendent of Parks, and James Ritchie, the Edinburgh clockmaker. The first clock only had an hour hand – a minute hand was added in 1904 and a cuckoo in 1905. The original clock mechanism was salvaged from Elie Parish Church. The mechanism for the clock is housed in the pedestal of the adjoining statue of Allan Ramsay. The popularity of Edinburgh's floral clock led to their widespread adoption as a prominent feature in civic bedding displays. The older image shows the clock in 1953 celebrating the coronation and the more recent image commemorates the contribution of the NHS during the Covid-19 pandemic.

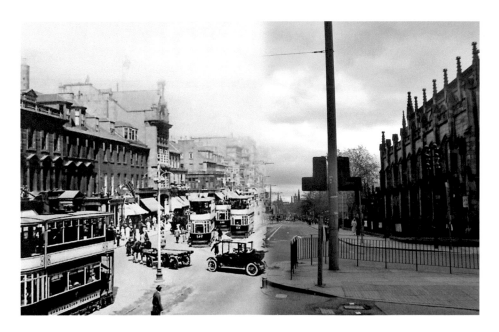

West End, Princes Street

Trams predominate as the main form of transport in the older image. In November 1871, the Edinburgh Street Tramways Company ran a 3.5-mile horse-drawn line from Haymarket to Bernard Street, Leith. In January 1888, a cable-hauled system was introduced which was electrified in 1922. The final day of the old trams fell on 16 November 1956. The new Edinburgh tramline opened on 31 May 2014. The monument in the middle of the road in the older image is the Catherine Sinclair fountain. It was erected in 1859 and was removed in 1926 to ease traffic flow. Catherine Sinclair (1800–64) was an author and was active in many charitable works in Edinburgh.

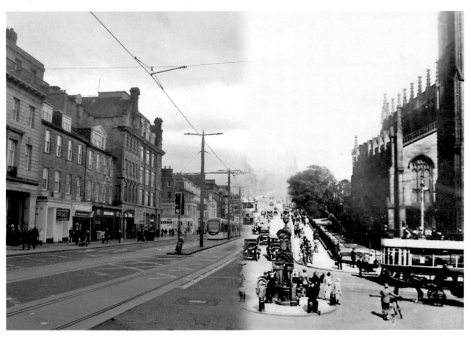

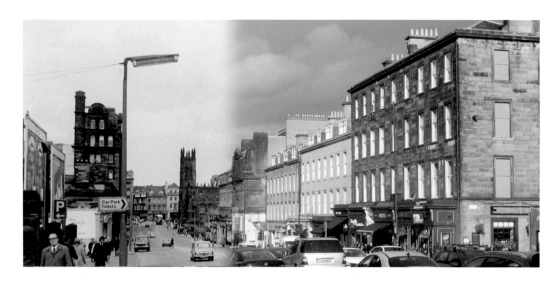

Lothian Road

These images are looking north on Lothian Road from opposite the Usher Hall. Princes Street and St John's Church terminate the views. Lothian Road was completed in 1785 to link the west end of Princes Street to Tollcross. The Caley cinema in the older image closed in 1984, was converted into a music venue and is now a pub. The goods entrance to Princes Street railway station was on the left of the older image. The Caledonian Railway Company first extended a line, served by a temporary wooden station on Lothian Road, into Edinburgh in 1848. By the 1890s, a new terminal had been built. The station closed in 1965 due to a combination of railway cuts and its inability to compete with Waverley station in terms of routes and accessibility. In the late 1970s, the rails were removed, and the railway line was used as the route of the West Approach Road. In the early 1980s, the site was redeveloped with a hotel, Festival Square and office blocks.

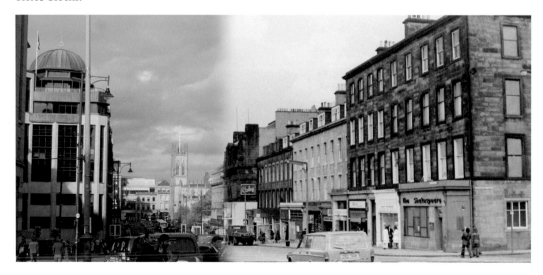

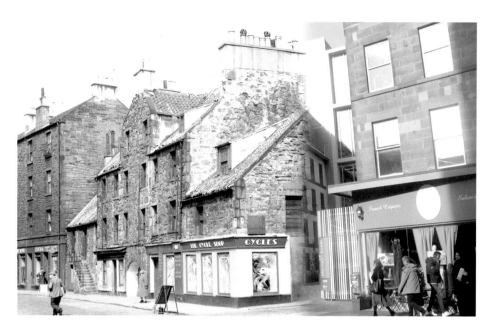

Castle Barns, Morrison Street

'Castle Barns was used for the accommodation of the Court when the King resided in the Castle, and it no doubt occasionally sufficed for such a purpose; but the name implies its having been the grange or farm attached to the royal residence, and this is further confirmed by earlier maps, where a considerable portion of ground, now lying on both sides of the Lothian Road, is included under the term.' (*Memorials of Edinburgh in the Olden Time*, Daniel Wilson, 1886). Castle Barns stood on Morrison Street opposite the junction with Semple Street. In 1849, it was opened as an industrial school by St Cuthbert's Church Session. The school closed in 1902 and it was used for congregational activities until 1967, by which time it needed considerable renovation. However, the costs were prohibitive, and it was demolished around 1967.

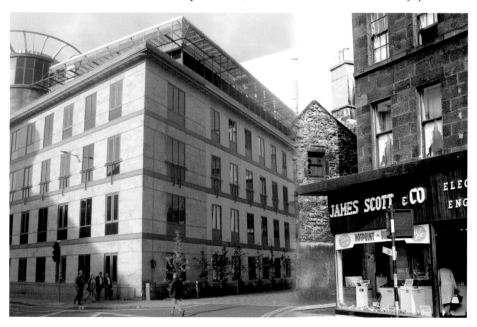

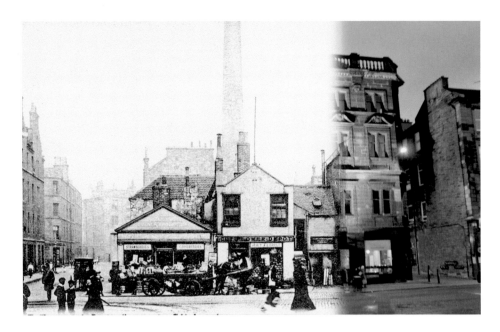

King's Theatre

The prominent site at the corner of Leven Street and Tarvit Street for the construction of the King's Theatre (*The Grand Old Lady of Leven Street*) was acquired in 1905. The original buildings on the site consisted of a group of retail outlets owned by Thomas J. Malcolmson, grocer and wine merchants, and the Drumdryan Brewery – the tall chimney of which can be seen in the older image. James Davidson designed the graceful symmetrical Edwardian Baroque red-sandstone exterior of the building with its neat double windows and ornate projecting central bay over the entrance. J. D. Swanston was responsible for the flamboyant interior, which contrasts with the rather stern frontage. The theatre opened for the first time on 8 December 1906 with a festive production of the pantomime *Cinderella*.

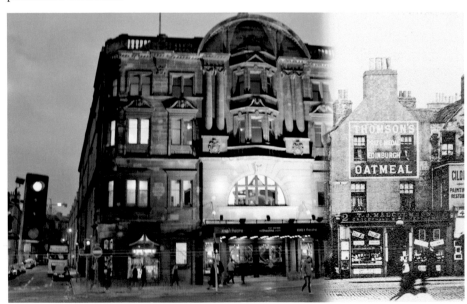

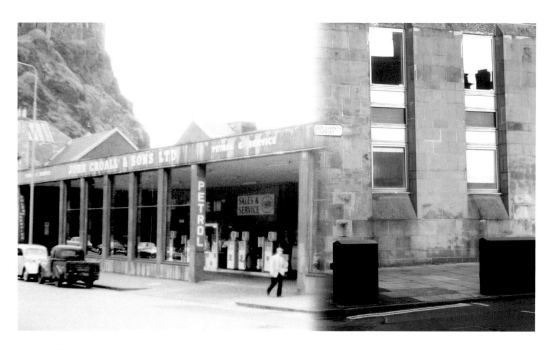

John Croall & Sons, Castle Terrace

In the nineteenth century, John Croall & Sons were operating the Royal Horse Bazaar from this site in Castle Terrace with regular sales of horses, carriages, harness and saddlery. By the 1900s, they had also moved into the sale of motor cars. The site was redeveloped for an office building and the Brutalist bulk of Argyle House in the 1960s.

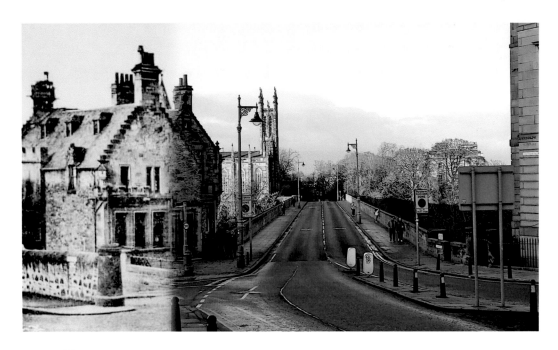

Dean Bridge

Dean Bridge was completed in 1831 to a design by Thomas Telford (1757–1834). It provided an important level access into the city over the Water of Leith, avoiding the steep inclines at Dean Village. The parapets were raised in 1912 to discourage suicides. The bridge was mainly funded by Lord Provost John Learmonth. It provided improved access to his lands to the west of the New Town and enhanced their development potential. The Scots Baronial Deanbrae House, to the left of the images, dates from 1892 and incorporates a late seventeenth-century tavern. The church in the background is the former Holy Trinity Church, which dates from 1837 to 1838. It was converted into an electricity substation in 1957 and is now being used again as a church.

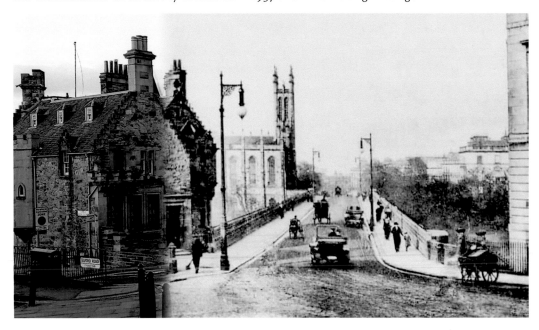

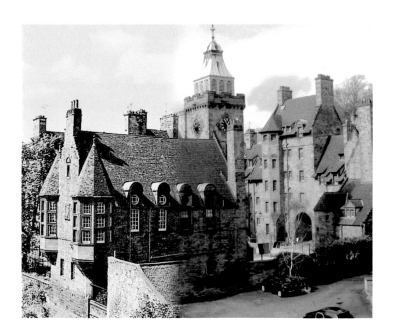

Well Court, Dean Village

Dean Village developed as a milling community at a fording point on the Water of Leith. The importance of Dean Village as a crossing point ended with the completion of Telford's Dean Bridge. In the early 1880s, the site of Well Court was occupied by some neglected tenements which were bought by Sir John Ritchie Findlay, the proprietor of the *Scotsman* newspaper. Findlay was distressed by the poverty of his less fortunate neighbours and commissioned a new development of social housing on the site – it had the additional benefit of improving the view from the rear of his house at Rothesay Terrace. Well Court was built in 1883–5 and forms a quadrangle of small flats with a detached former social hall around a central courtyard. The small astragalled windows, crowstep gables, turrets and flamboyant roofscape all contribute to Well Court's picturesque character.

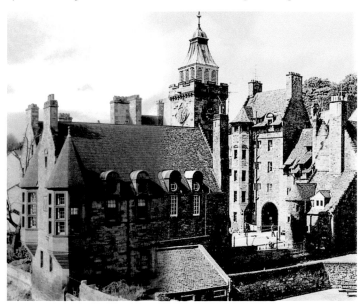

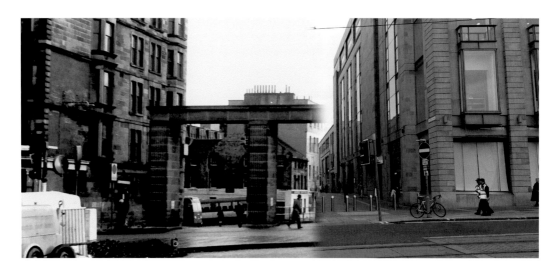

Bus Station, St Andrew Square

Edinburgh Corporation introduced its first bus in 1914 and, in 1928, given the increasing importance of buses, the Edinburgh Corporation Tramways Department was renamed the Edinburgh Corporation Transport Department. Trams had still outnumbered buses until as late as 1952; however, after the decision to concentrate public transport on buses, 370 new and seventy-seven refurbished buses were ordered in the 1953–7 period. The main bus station with its distinctive archway at St Andrew Square opened in April 1957 on the site of a former cinema which was destroyed by a fire 1952. The distinctive stone portico was intended to help it blend in with the neighbouring buildings. The Multrees Walk development now occupies the site.

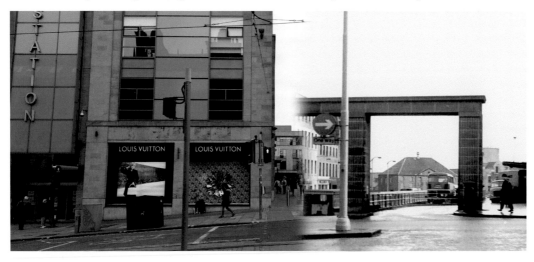

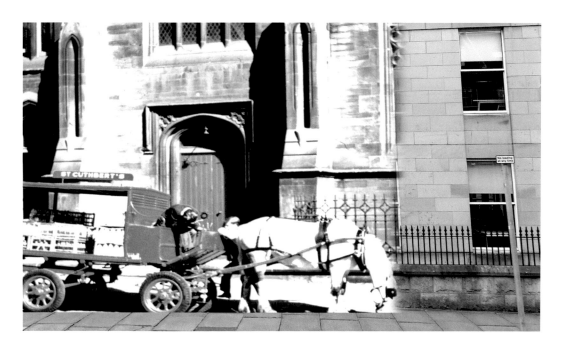

St Cuthbert's Milk Float, Albany Street

A St Cuthbert's milk float taking a break in the older image. Morning milk deliveries accompanied by the clip-clop of hooves, which was an Edinburgh tradition for 125 years, ended on 26 January 1985. The milk float is standing in front of the Albany Street frontage of St Mary's Free Church on the corner of Broughton Street and Albany Street. The church dated from 1860 and, with its 180-foot spire, was a landmark feature. In the 1950s, the building was used by the theatrical costumiers Mutries. The church was demolished in 1983 and replaced by a modern office building. The Gothic-inspired building at 56 Albany Street was the manse of the original church.

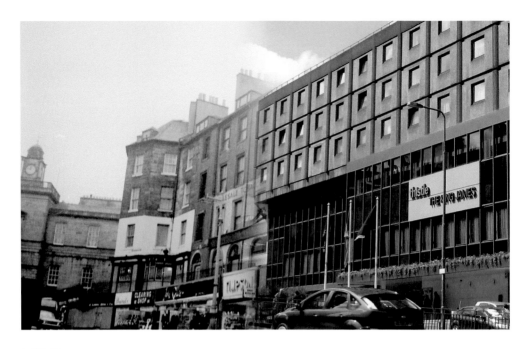

Leith Street

Many of the properties around Leith Street, Greenside and St James Square were swept away during extensive redevelopment of the area between 1966 and 1972. St James Square was built between 1775 and 1790 to a design by James Craig, the architect responsible for the plan of the New Town. In the 1960s, the development had deteriorated into what were considered slum conditions and comprehensive redevelopment was proposed in 1963. The north side of Leith Street and its characterful terrace disappeared in 1969 along with its array of shops to make way for the St James Centre, a large store, and an office development for the Scottish government (New St Andrew's House).

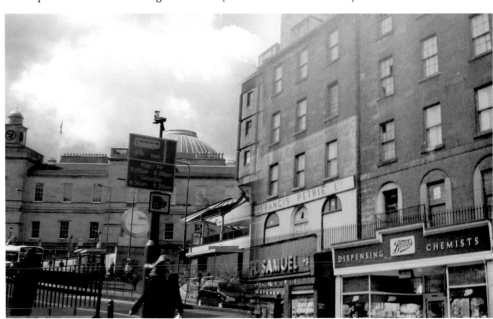

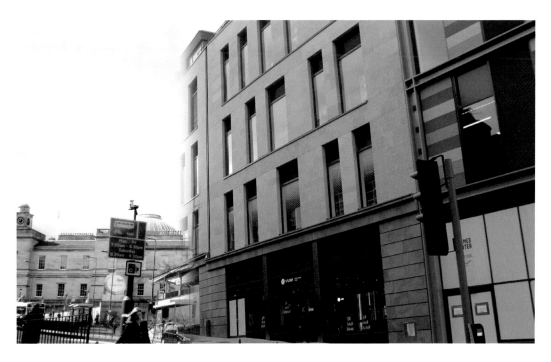

Leith Street

The St James Centre closed in 2016 and was replaced by the St James Quarter, a large new shopping centre which opened in June 2021.

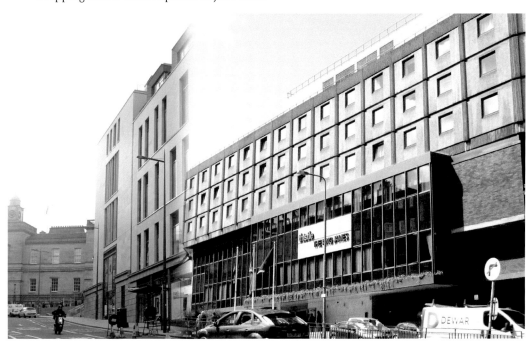

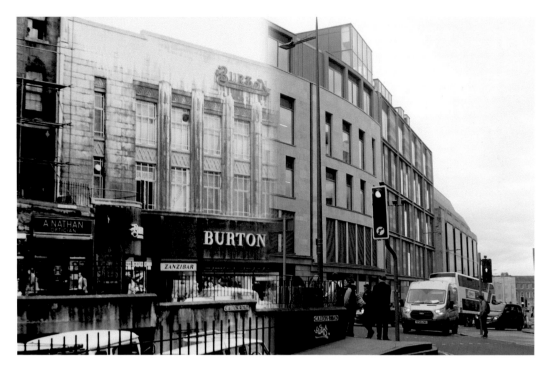

Leith Street

The Burton and Alexander shops in the older image were just two of the many clothing shops on Leith Street. It was a main destination in Edinburgh to purchase a sharp suit for a night at the dancing during the 1950s and '60s.

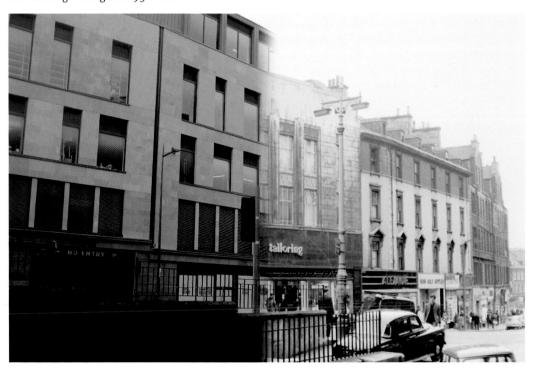

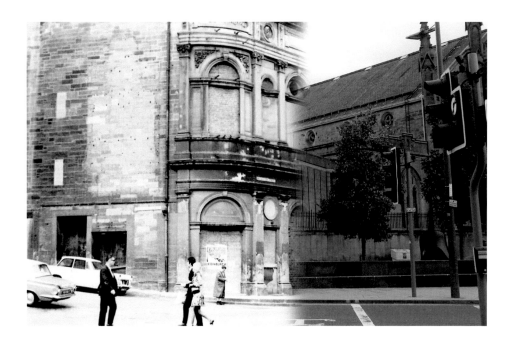

The Theatre Royal, Broughton Street

The Theatre Royal prior to its demolition in the late 1950s is shown in the older image. The theatre was damaged by fires on several occasions. After the final fire in 1946, the building stood as an empty shell for several years, until finally being demolished. The medallions depicting Molière, Shakespeare, Sir Walter Scott and Dante at the upper level of the building were salvaged and are now on display at the top level of the stairway at the Festival Theatre. The site is now occupied by an extension to St Mary's Cathedral.

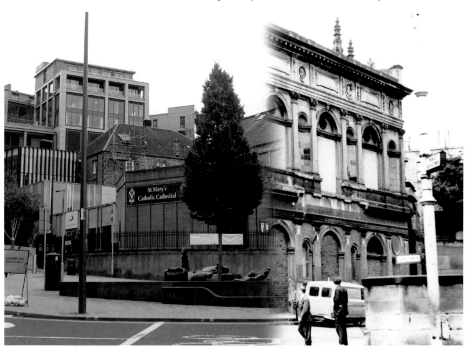

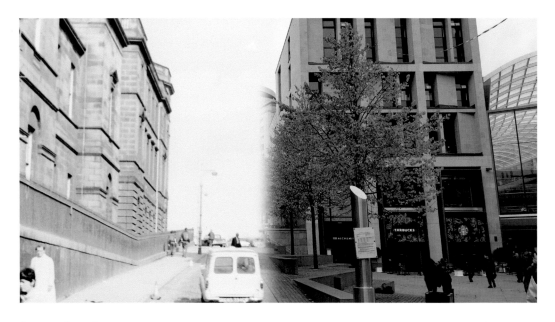

East Register Street

East Register Street was formerly a road linking Leith Street to St James Square. Since the construction of the St James Centre, it has been a pedestrian link running along the east side of Register House. The Register Tap pub in the older image was one of the many properties demolished to make way for the St James Centre. The more recent image shows the entrance to the new St James Quarter and the ribbon hotel building.

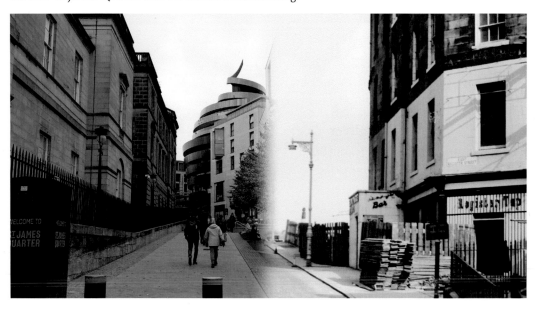

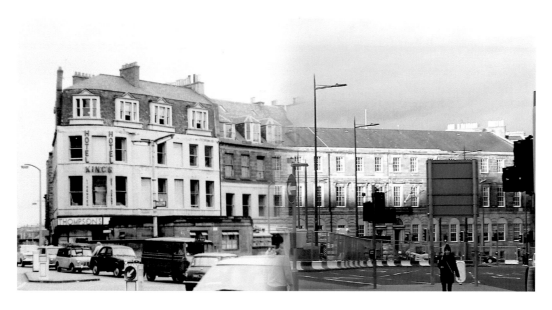

Union Place

The terrace of buildings in the older image formed the southern section of a triangular block of properties at the top of Broughton Street, which was demolished and replaced by a roundabout in 1969. The Abercrombie Plan envisioned the roundabout connecting to a tunnel through Calton Hill and linking to a new motorway in the Old Town. The demolition involved the loss of the south side of Picardy Place, including the birthplace of Sir Arthur Conan Doyle. Bandparts and the original Deep Sea fish and chip shop were two of the well-known commercial premises on the terrace. At the time of writing, work was underway to construct the tramline to Leith and reconfigure the roundabout.

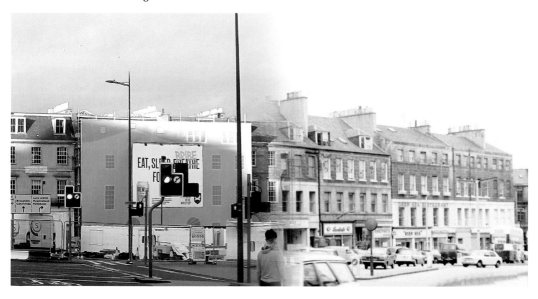

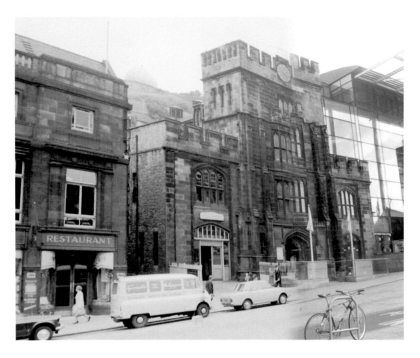

Lady Glenorchy's Church, Greenside Place

Lady Glenorchy (1741–86) founded several chapels in Scotland. In 1733–4, she funded the first in Edinburgh at Low Calton. This was demolished in the mid-nineteenth century to make way for Waverley station and the congregation moved into a new building on Greenside Place in May 1846. In 1978, the church was abandoned by the congregation and was subsequently used for a variety of commercial purposes. In 2002, the crenelated Gothic façade of the building was incorporated into the Omni Centre.

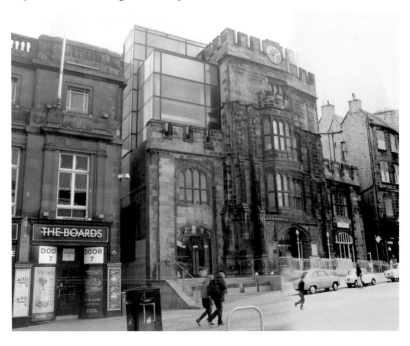

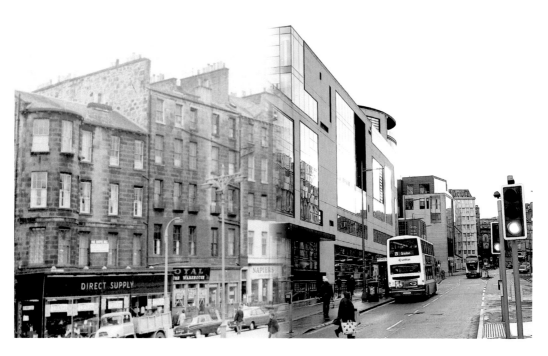

Greenside

The tenements in the older image were demolished in the 1970s as part of the comprehensive redevelopment of the area. The site was not fully developed until the opening of the Omni Centre and offices in 2002.

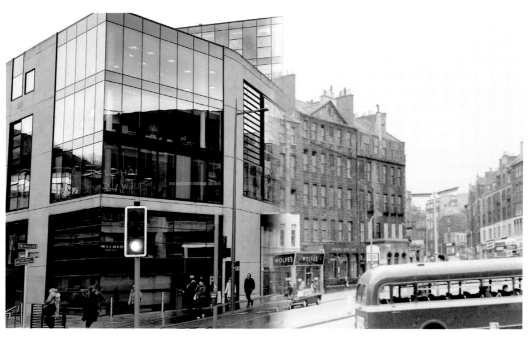

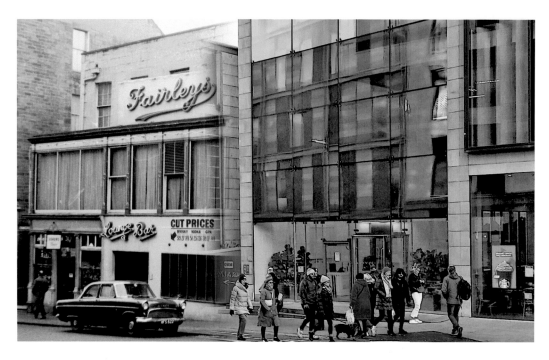

Jerome and Fairley's, Leith Street

Jerome's was established in 1928 and had multiple photographic studios throughout the United Kingdom. The Edinburgh shop was based at 79 Leith Walk and was in operation from 1934 until 1970. Many Edinburgh households will have portrait photographs of family taken at Jerome's – several of which seemed to feature a fluted pillar. Fairley's was a popular dance hall, bar and restaurant which was responsible for the beginning of many an Edinburgh courtship.

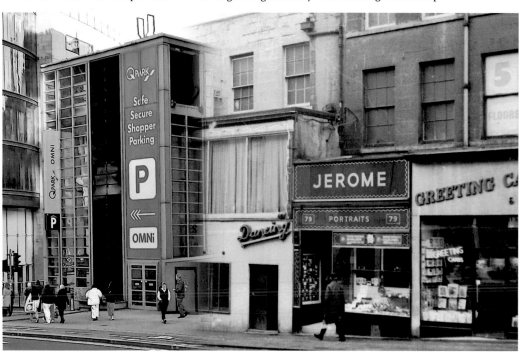

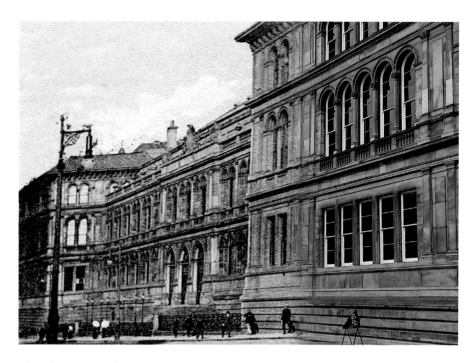

National Museum of Scotland, Chambers Street

The foundation stone of the Industrial Museum of Scotland on Chambers Street was laid on 23 October 1861 by Prince Albert – his last public act. It housed a vast collection devoted to natural history, industrial art, and the physical sciences. In 1866, it was renamed the Edinburgh Museum of Science and Art and, in 1888, became the Royal Scottish Museum. In 2006, The Royal Scottish Museum was merged with the adjoining Museum of Scotland as the National Museum of Scotland.

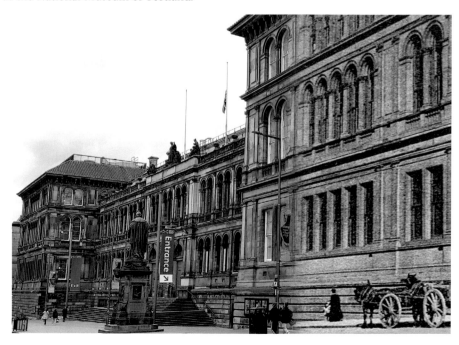

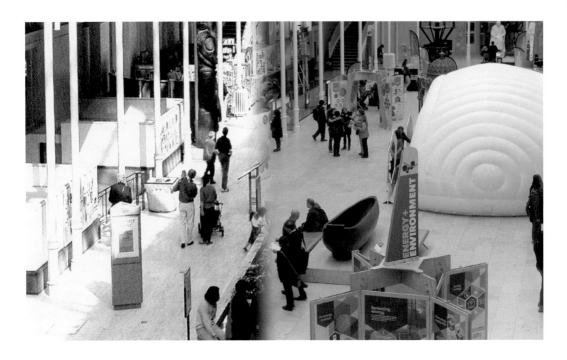

National Museum of Scotland, Great Hall

The aim of the museum's original architect, Captain Fowkes of the Royal Engineers, who also designed the Royal Albert Hall, was to maximise natural light in the building and the Great Hall has a magnificent glass roof, modelled on the Crystal Palace. The building underwent a major refurbishment and reopened in July 2011. Many locals have since lamented the loss of the fishponds, which were a fondly remembered feature of the Great Hall. The pond filtration tanks were removed from the basement which was redeveloped into the entrance foyer. The fish were moved to the Kibble Palace greenhouse at Glasgow Botanic Gardens.

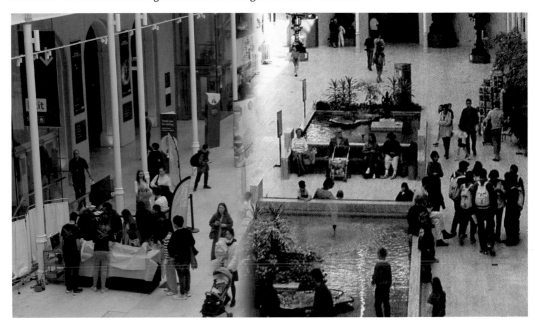

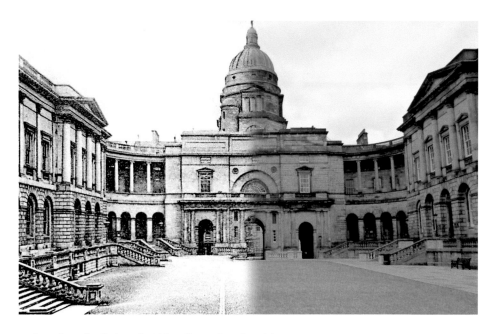

University of Edinburgh Old College, South Bridge

The Old College of the university is one of the most notable and important academic buildings in Scotland. The design, by Robert Adam, included two internal courtyards and it was intended as the centrepiece of an ambitious overall plan which was never achieved. Work began in 1789, but was halted in 1793, with only the north-west corner and main frontage completed, following the death of Adam in 1792 and the outbreak of the Napoleonic War. In 1818, William Playfair completed the building with only one large colonnaded quadrangle. In 1887, the landmark dome, which had been part of Adam's original design, was added. The dome is crowned by the Golden Boy – a statue of Youth holding a torch and symbolising knowledge. The magnificent quadrangle was re-landscaped in 2010 with a new lawn – in previous years it had been used as a car park.

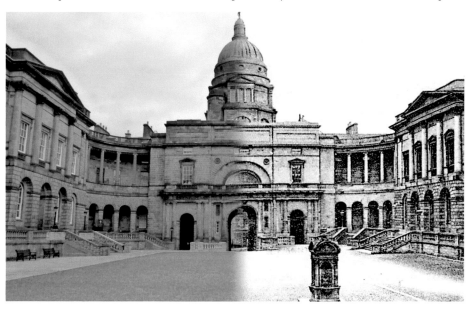

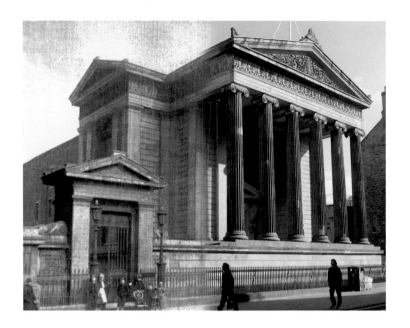

Surgeons' Hall, Nicolson Street

The Royal College of Surgeons of Edinburgh is one of the oldest surgical institutions in the world. In 1505, the Barber Surgeons of Edinburgh were first recognised as a Craft Guild. In 1647, they established a permanent meeting place in Dickson's Close. In 1697, they moved into Old Surgeons' Hall in High School Yards. In 1778, King George III granted a charter giving the surgeons' corporation the title 'The Royal College of Surgeons of the City of Edinburgh'. By the beginning of the nineteenth century, larger premises were required to house the collection of pathological specimens, including a full-sized elephant. A site on Nicolson Street, occupied at the time by a riding school designed by Robert Adam, was acquired. The new Greek Revival-style building, with its Ionic-columned portico, was designed by William Henry Playfair and opened in July 1832. In 1851, Queen Victoria granted a new charter giving the college its present title.

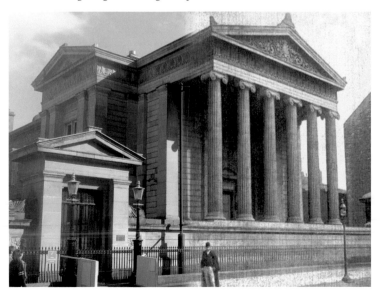

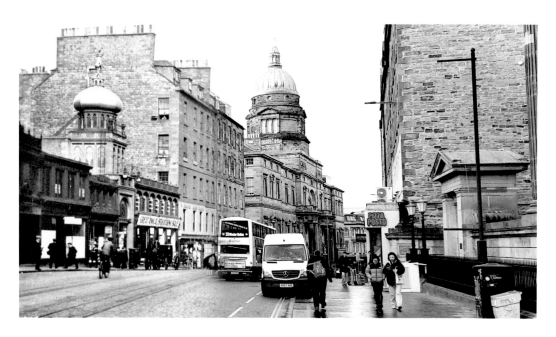

Empire Theatre

These views are looking north from Nicolson Street with the Old College in the middle distance and Surgeons' Hall on the right. The building with the onion-domed tower was the Empire Palace Theatre, which first opened on 7 November 1892. The site had been occupied by a succession of circuses and performance halls since 1830. The Empire Palace closed in November 1927 and was replaced by the Empire Theatre. In 1962, it was sold to Mecca, and in 1963 reopened as the New Empire Casino to cater for bingo. In 1992, bingo was falling out of favour. The local authority purchased the building, and it was leased to the Edinburgh Festival Theatre Company. The old frontage was replaced with a concave glass and steel façade, the backstage was rebuilt, and a new stage constructed. The 1928 auditorium was embellished and restored to its original grandeur. The new Festival Theatre opened on 18 May 1994.

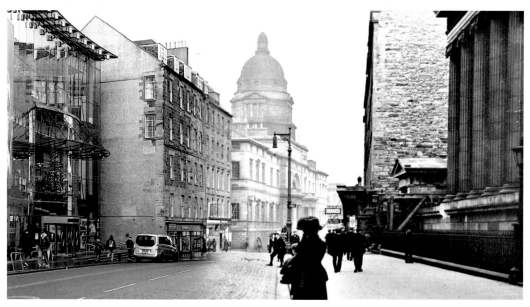

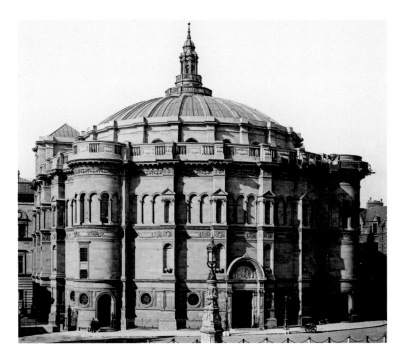

McEwan Hall, Bristo Square

The McEwan Hall was funded by Sir William McEwan (1827–1913), the Edinburgh brewer who established the successful Fountain Brewery in Edinburgh in 1856. McEwan was the Member of Parliament for central Edinburgh and gave £115,000 to the University of Edinburgh to erect a graduation hall. The design for the building was selected by competition and the architect, Sir Robert Rowand Anderson, was so determined to win that he made a rapid tour of public buildings in England and the Continent before submitting his entry to the competition. Bristo Square, which was first laid out in 1983, following the diversion of local roads, provides a setting for the McEwan Hall.

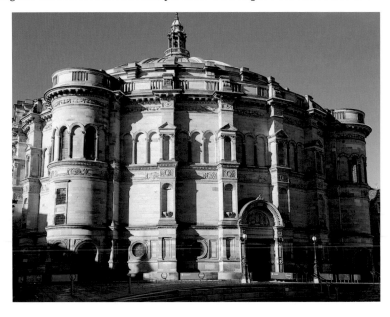

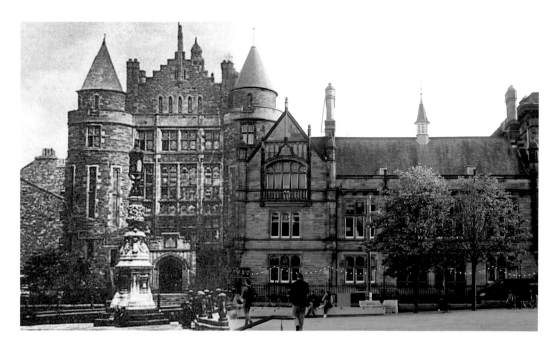

Teviot Row House, Bristo Square

The students at the University of Edinburgh celebrated the opening of Teviot Row House on 19 October 1889 with a torch-lit procession through the city. The students raised the funds to build the Union, which is the oldest purpose-built students' union in the world. The original imposing design is influenced by sixteenth-century Scots-Renaissance architecture. Spirits were only permitted to be sold in the Union from 1970, and in 1971 there was a major constitutional change which allowed women access to the Union building. Prior to the building of the Union, the site was occupied by Lord Ross's house which dated from *c.* 1740, and later became a lying-in hospital from 1793 to 1842.

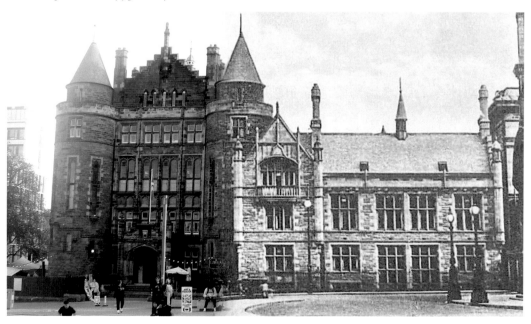

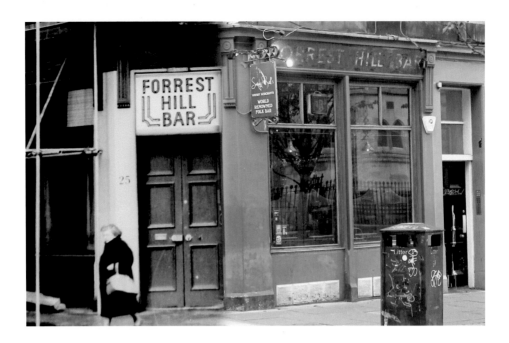

Sandy Bell's, Forrest Road

The site of Sandy Bells's started life as a local grocery shop. By the 1920s, it was a pub owned by a Mrs Bell and going by the official name of the Forrest Hill Buffet and later the Forrest Hill Bar, although in recent memory it has always been known as Sandy Bell's – it is likely that Sandy was a barman at Mrs Bell's pub. Sandy Bell's claim to fame is its association with the Scottish folk music revival of the 1960s and its continued use as a venue for live music. Jimmy Cairney, the landlord in the 1960s, was a devotee of traditional music. He encouraged young musicians to play in the pub and turned Sandy Bell's into one of the leading folk music venues in Scotland.

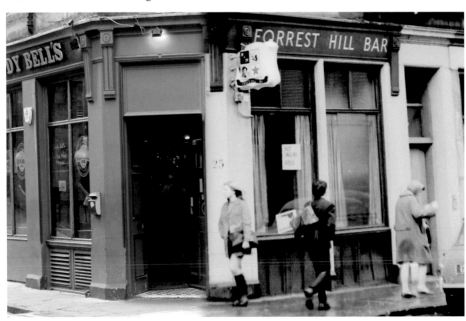

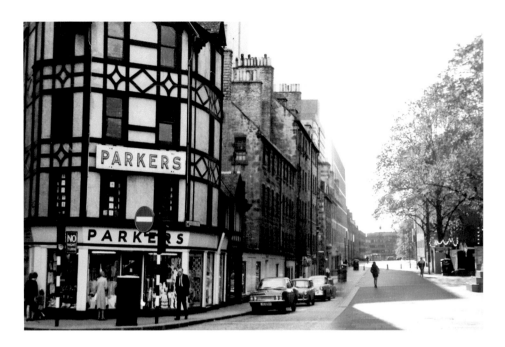

Parker's Stores

Parker's Triangle was the name associated with the tenement block formed by Bristo Square, Crichton Street and Charles Street, which stood between the present Appleton Tower and Bristo Square. The Triangle took its name from Parker's Stores which occupied a building with a distinctive mock-Tudor half-timbered frontage – a thin cladding added to the old stone façade, at the corner of Bristo Street and Crichton Street. It was a popular haberdashery and many Southsiders of a certain age will remember being fitted out for their school uniforms in the shop. The buildings were cleared in 1971. The triangle had been built between 1770 and 1780 by James Brown, who also developed George Square.

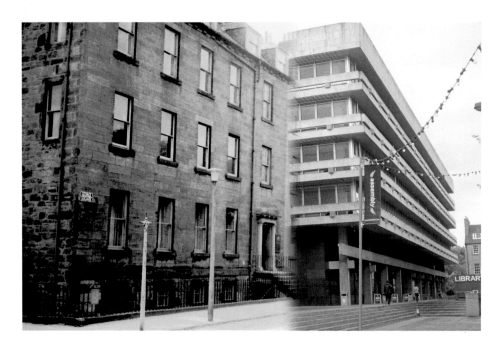

George Square

These images show the south side of George Square where the terrace of original buildings was replaced by the George Square Theatre and University Library. The library, which opened in 1967, is a key work of Sir Basil Spence, Glover and Ferguson. The university's brief was for a building that could hold two million books and cater for up to 6,000 students daily. The building is eight storeys high, and each floor is an acre in area – making it the largest university library in Britain. The bulk of the building is cleverly disguised by the horizontal projecting cantilevered balconies, which also provide shading from the sun. It received several design awards and was listed at Category 'A' in 2006, denoting its national importance.

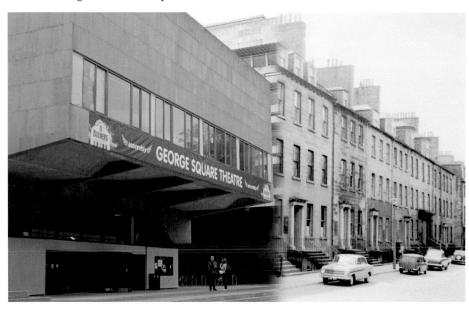

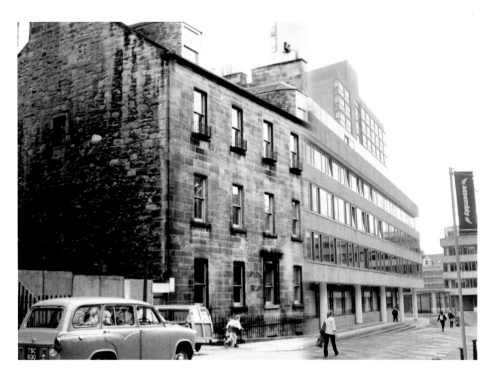

George Square
The original buildings on the south-west side of the Square, which accommodated the Women's Union, were redeveloped for the William Robertson Building, named after a distinguished eighteenth-century historian. The David Hume Tower (now known as 40 George Square) is in the background.

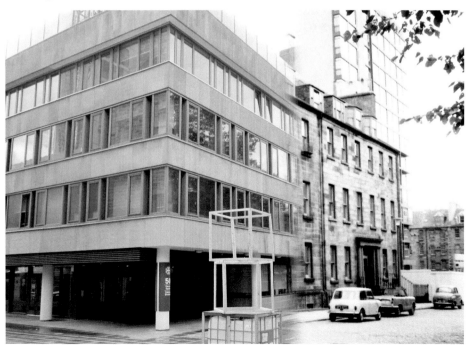

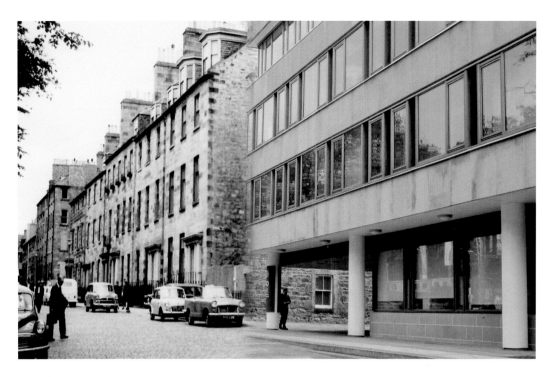

George Square

The east side of George Square looking out towards Bristo Square. The street which runs between the buildings in both images is Windmill Street, which still connects the Square to Chapel Street. The name refers to an old windmill that was located near the site of Buccleuch Parish Church. It was used to pump water out of the Borough Loch for use in local breweries.

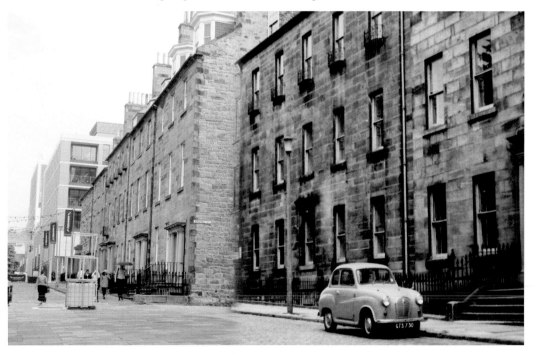

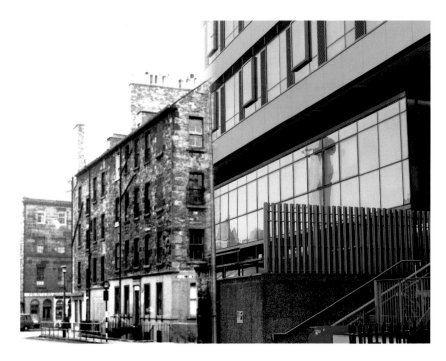

Crichton Street, Appleton Tower

The tenements in the older image were replaced by Appleton Tower which was completed in 1966. It was the early stage of a much more extensive proposed development by the university that would have covered much of the South Side. The tower was named for Sir Edward Appleton, who was principal of the university and one of the main proponents of the university's expansion plans. Windmill Lane, which linked Crichton Street and Buccleuch Place, was lost in the development.

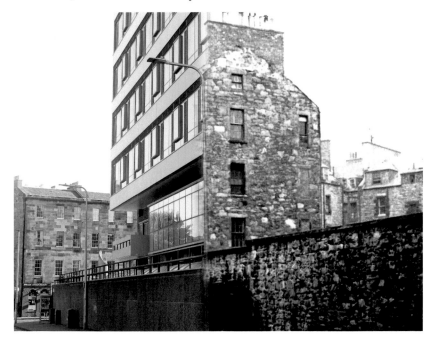

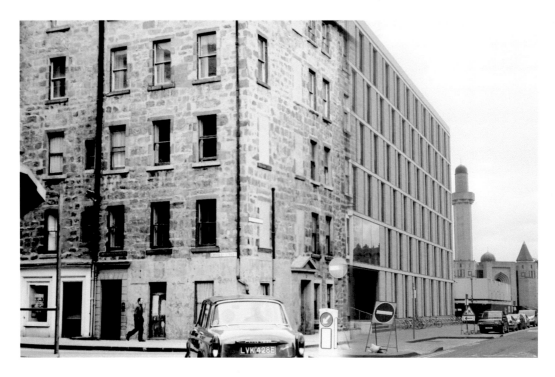

Crichton Street

It was intended that Appleton Tower would link to university buildings on the opposite side of Crichton Street and the tenements in the older image were demolished in the 1960s. The proposals were abandoned and the site was used as a car park until 2007, when the university's Informatics Building was built.

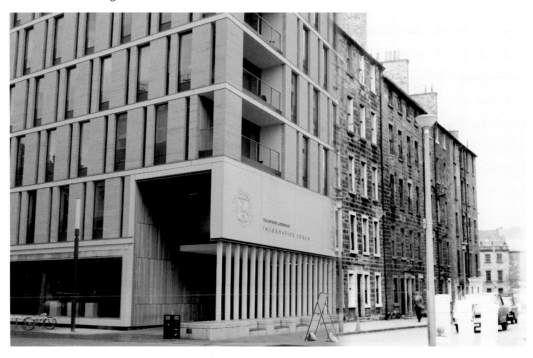

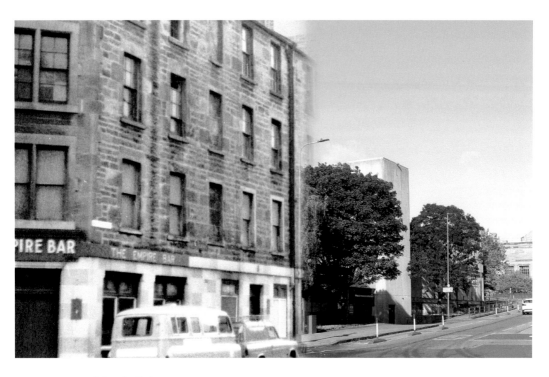

Potterow/Marshall Street

These views are looking north on Potterow. The Empire Bar was on the corner of Potterow and the now lost westward extension of Marshall Street. Marshall Street was the site of one of the bombs dropped from a German Zeppelin on 2 April 1916. There were six fatalities on the street from blast debris from the bomb.

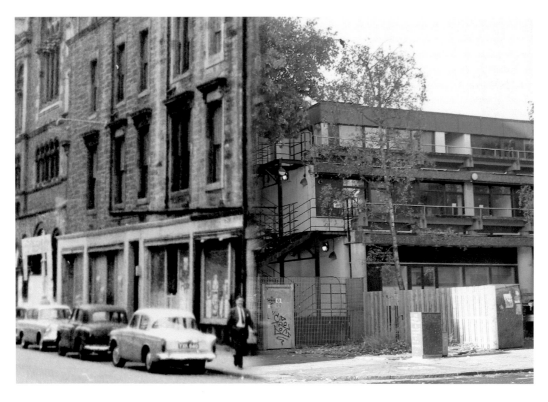

Marshall Street/Potterow
These views are looking along the original westward extension of Marshall Street towards Bristo Square. The building with the ornate windows in the older image was the Barrie Theatre.

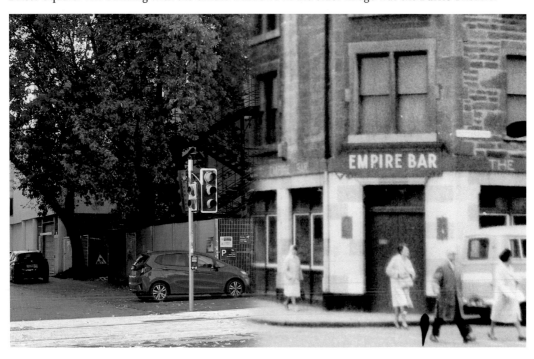

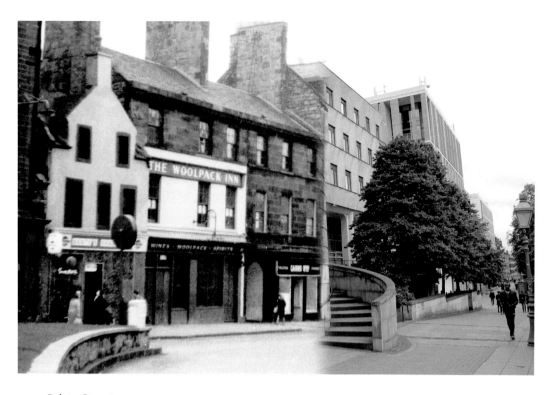

Bristo Street

Bristo Street ran from the corner of Crichton Street and Potterow through to Bristo Place. This part of the street was opposite the McEwan Hall. The Wool Pack pub was a well-known local South Side hostelry.

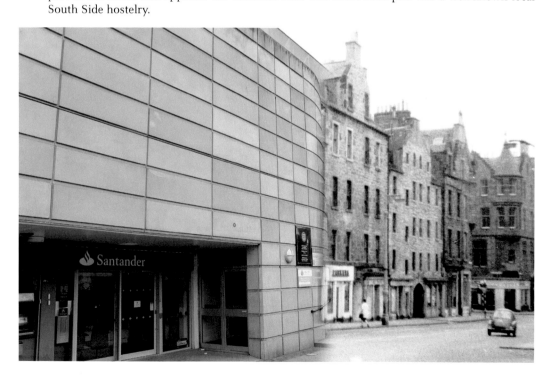

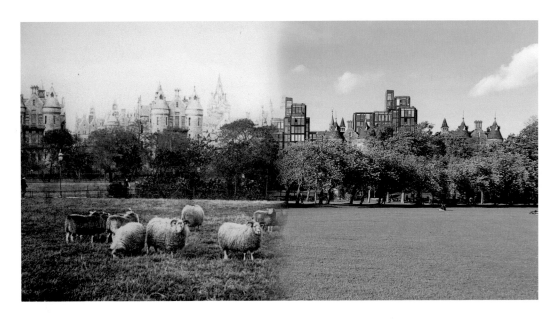

The Meadows

The Meadows form one of the most important areas of open space in Edinburgh. Over the centuries, they have provided room for a range of activities – including sheep grazing, judging by the older image. In 1917, it was noted that the revenue which the Town Council received for grazing in the Meadows was £10. The Meadows was the site of the Borough Loch. In the sixteenth century it formed the main water supply for Edinburgh, until the level of the water was much reduced by local breweries. In 1657, the Town Council decided to drain the Loch, and John Straiton, a merchant burgess, was given lease of the loch. Straiton's efforts were ultimately unsuccessful. In 1722, Thomas Hope of Rankeillor leased the loch and attempted to convert the marshland into an ornamental park.

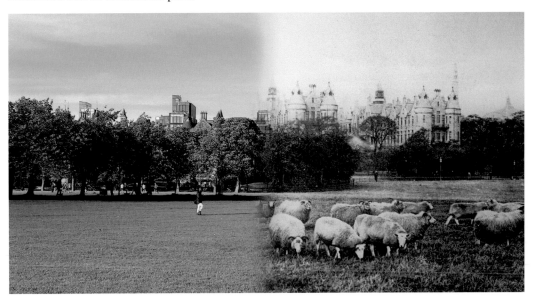

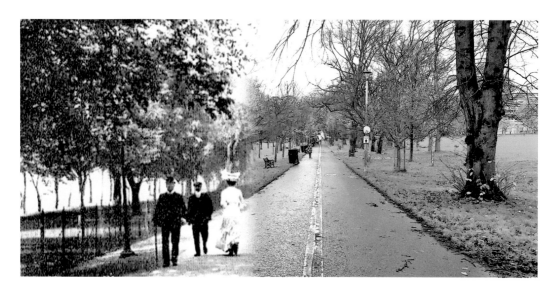

Middle Meadow Walk

Edinburgh Town Council began the reconstruction of the Meadows in 1804. However, after many delays, it was not until the mid-nineteenth century that paths were laid out and the public had access to the Meadows. As the city grew, early concerns about potential development in the Meadows resulted in the Edinburgh Improvement Act of 1827 which secured the Meadows for the public good and prohibited any development in the Meadows or Bruntsfield Links. The railings on the edge of the path in the older image were removed in 1917 to improve the appearance of the park and 'provide material for munitions of war'.

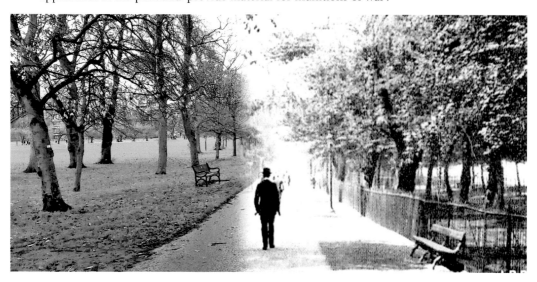

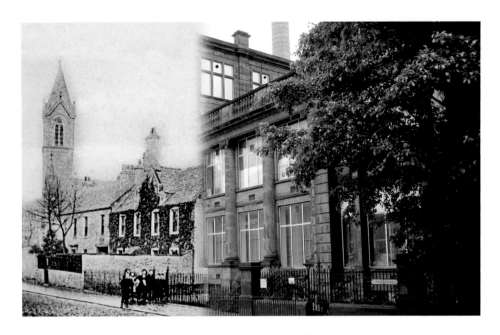

Royal (Dick) School of Veterinary Studies, Summerhall

The Royal (Dick) School of Veterinary Studies (or the Dick Vet as it is more commonly known) was founded by William Dick (1793–1866), who studied anatomy in Edinburgh and attended the London Veterinary College. In Edinburgh, he established his own veterinary school – the first in Scotland – at Clyde Street in 1819. In 1906, the college was named the Royal (Dick) Veterinary College by Act of Parliament. The college moved to custom-built premises at Summerhall in 1916. Bryson's Brewery along with the cottages and the United Presbyterian Church in the older image were swept away for the new building. In 2011, the school moved to the Easter Bush campus and the building is now in use as a hub for the arts.

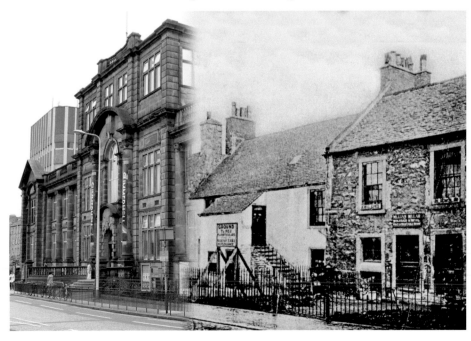

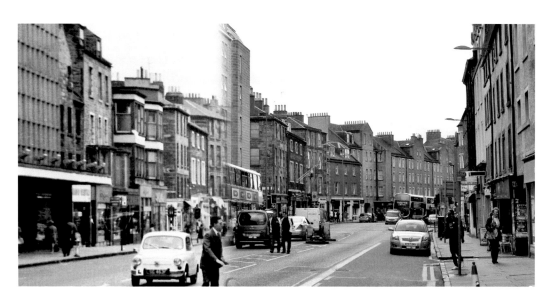

Nicolson Street

It is a busy scene in both of these views, looking south on Nicolson Street. Most of the buildings on the left side of the earlier images were the premises of St Cuthbert's Co-operative Society. Co-operative societies allowed customers to obtain membership, effectively becoming stakeholders in the company. Each customer was assigned their own specific five- or six-digit dividend number or 'divi'. Crawford's the bakers in the older image was an Edinburgh establishment with shops all over the city. The business first opened in 1899 and finally closed in 1996, when it lost the 'bread wars' with the large supermarket chains. It looks like the driver of the Southern School of Motoring in the older image may be having problems with a traffic warden. The first parking meter in Edinburgh was installed for display purposes outside of the City Chambers in October 1960 – they were soon a major feature of the city.

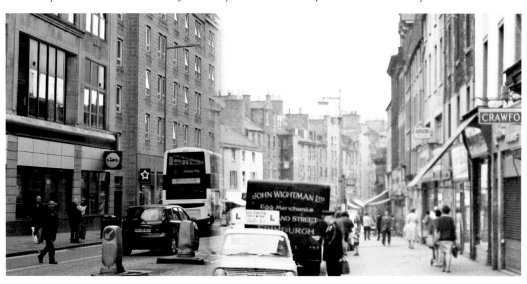

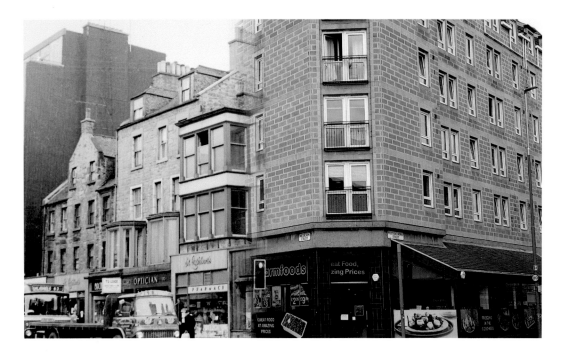

Nicolson Street/West Richmond Street

The picturesque group of buildings, including St Cuthbert's shoe shop and pharmacist, in the earlier image was replaced by a single large block of flats during the redevelopment of the South Side. The first St Cuthbert's Co-op store opened on 4 November 1859 on the corner of Ponton Street and Fountainbridge. 'The Store', as St Cuthbert's was generally known, boasted the highest sales of any co-operative society in the UK, paying out millions in dividends.

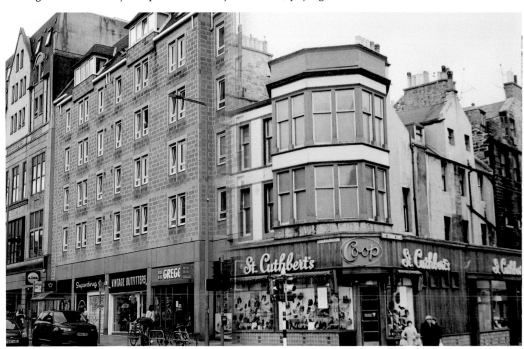

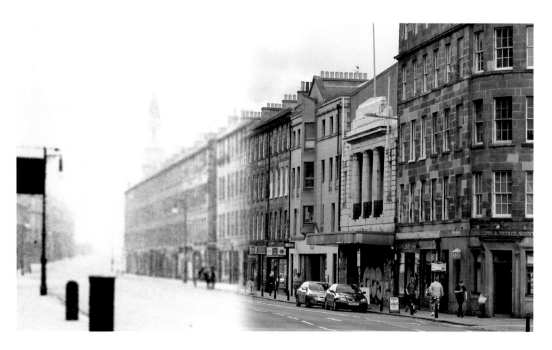

Clerk Street

These images are looking south on Clerk Street from St Patrick Square. Clerk Street takes its name from William Clerk who was the owner of ground around St Patrick Square. The street was developed with substantial tenements from around 1810 on the estate of Major John Hope. The lower building on the right of the older image was demolished to make way for the New Victoria Cinema, which opened on 25 August 1930. It was designed by the prominent cinema architect William Edward Trent and is recognised as an exceptional example of an art deco picture palace. The name changed to the Odeon in 1964. In August 2003, the cinema closed and there has followed a long period of uncertainty about the future of the building.

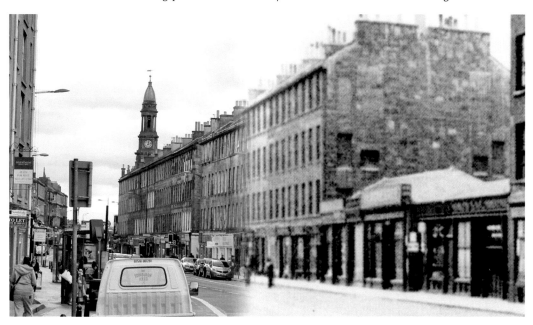

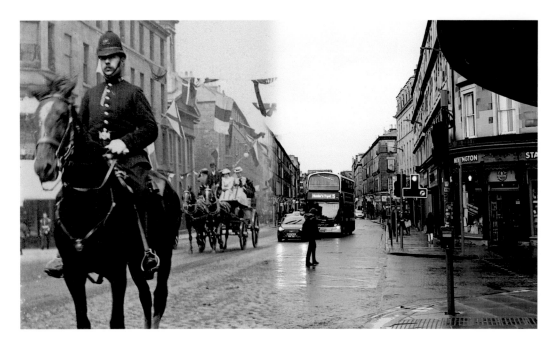

South Clerk Street

These images show South Clerk Street at its junction with Hope Park Terrace and Bernard Terrace. In the older image, the street is decorated with bunting for a visit by King Edward VII and Queen Alexandra in May 1903 to commemorate King Edward's Coronation in London the previous year. The spire of the Queen's Hall is prominent in both images. The Queen's Hall was originally built as the Hope Park Chapel of Ease in 1823. In 1834, it was renamed Newington Parish Church and later Newington and St Leonard's Church. When the buildings closed as a church, it was converted to a music venue and was formally opened by Queen Elizabeth II on 6 July 1979.

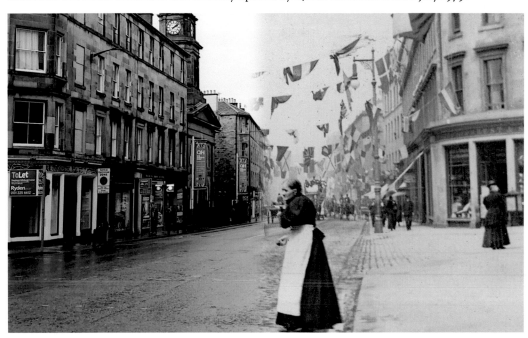

Causewayside

These are views of Causewayside from West Preston Street. The buildings on Causewayside were demolished for the construction of new flats in the 1980s. The building in the background was part of Bertram's St Katherine's Engineering Works. Bertram's was an engineering firm which designed and manufactured paper-making machinery. The factory closed and was redeveloped for housing around 1985. The production of paper-making machinery by Bertram's was closely related to Edinburgh's long association with printing – contributing to the maxim that Edinburgh was known for the three Bs: beer, biscuits and books. Causewayside linked Edinburgh to Liberton and it was causeyed in the sixteenth century. Causey is from the Old French *caucie*, meaning a paved road.

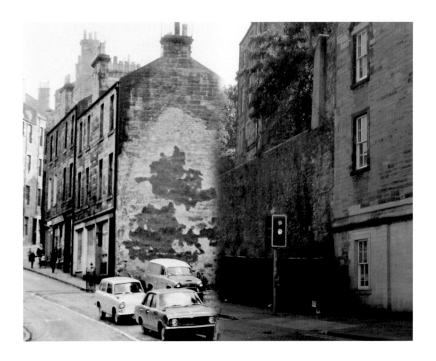

Pleasance

These are views from the Cowgate looking south to the Pleasance with the Salvation Army Hostel on the right foreground. The tenements in the older image, which stood in front of a section of the Flodden Wall, were demolished in the 1960s. Edinburgh was historically protected by a wall on three sides and by the Nor' Loch to the north. An earlier King's Wall enclosed a small portion of the current Old Town. This was extended after the defeat of the Scottish army at the Battle of Flodden in 1513. The name, the Pleasance, derives from the Scots *pleasance*, meaning a park or garden, which was the name of a sixteenth-century house in the area.

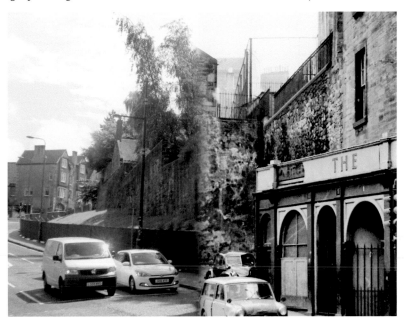

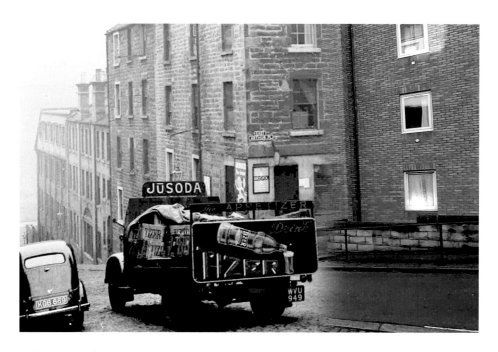

Arthur Street/East Arthur Place

The tenements in the Dumbiedykes area dated from the early part of the nineteenth century. Arthur Street was a steep road running from the Pleasance down to Dumbiedykes Street, which ran along the edge of Holyrood Park. A short section of the original Arthur Street at the Pleasance is now called New Arthur Place and retains its cobbled road surface. East Arthur Place was one of three streets – along with West Arthur Place and Middle Arthur Place which ran south from Arthur Street. The 'juice' lorry in the older image advertises *Jusoda* and *Tizer*. This was a time when juice bottles had a returnable deposit, and they were the equivalent of glass money for kids – collect enough and a free bottle of your favourite juice was secured.

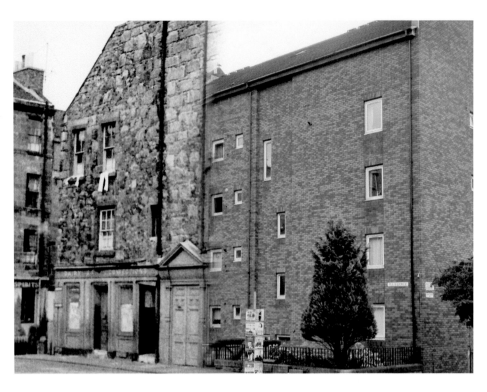

Pleasance, Brown Street

The building in the older image faced West Richmond Street with Brown Street to the south and Salisbury Street to the north.

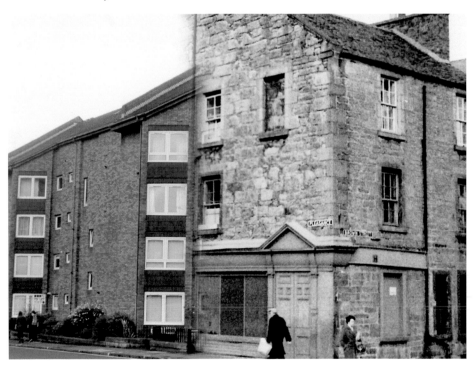

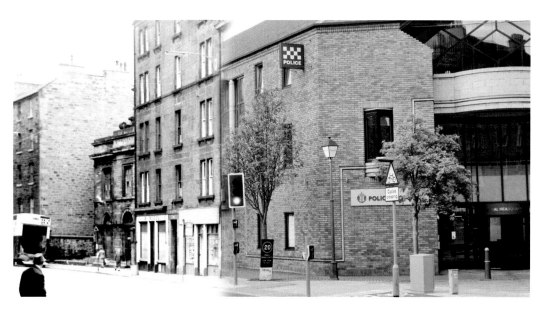

St Leonard's Street/St Leonard's Lane

The group of tenements in the older image was replaced by the St Leonard's Police Station. The building set back from the line of the tenements was St Paul's Free Church.

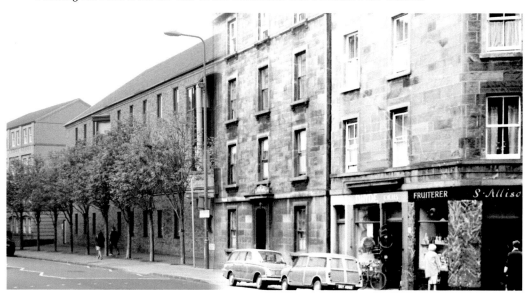

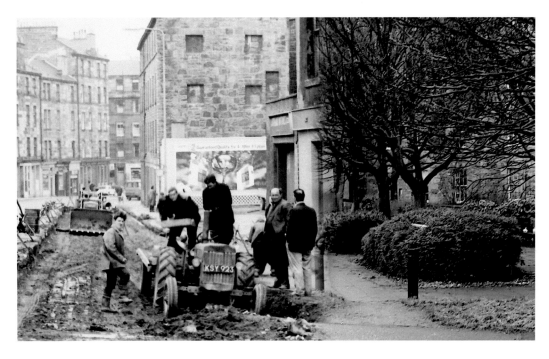

St Leonard's Street/Henry Street

A small group of onlookers are taking an interest in the roadworks underway at the junction of St Leonard's Street and Henry Street. The tenements in the right foreground in the older image were demolished and Henry Street became the entrance to a DIY store, which is now a student housing development.

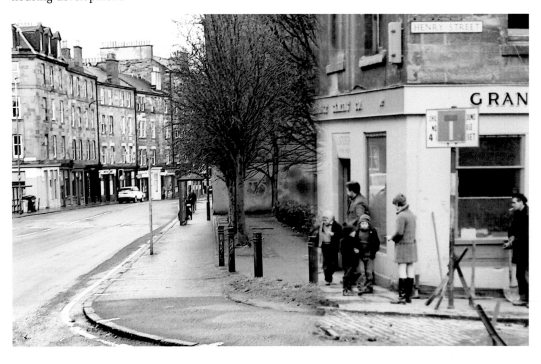

Castle o' Clouts, St Leonard's Street

The quaint-looking tenement, next to the former St Leonard's Church, in the older image dated from 1724. The ground floor was the Castle o' Clouts, a public house for well over 200 years. It was one of the first buildings reached by travellers entering the city by the road from the south. It was built by William Hunter, a prosperous tailor, who named the building Huntershall. However, based on Hunter's profession, it became known as the Castle of Clouts (Cloth). The building was demolished in 1969 and replaced by a DIY store, which was demolished in 2015 and replaced by student flats.

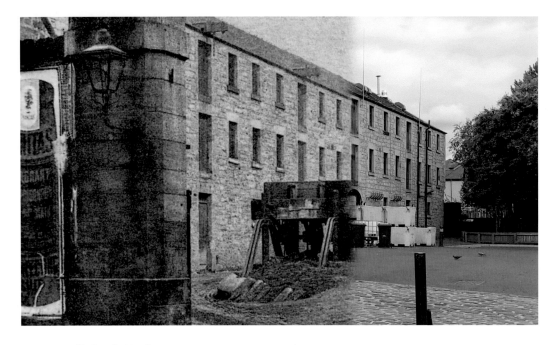

St Leonard's Goods Yard

The images show the original engine shed at St Leonard's railway station The demand for coal in Edinburgh led to the construction of the first railway in the Lothians, when the Edinburgh and Dalkeith Railway opened in 1831. It was known as the 'Innocent Railway', possibly because it was originally horse drawn (until 1846) in an age in which many considered steam engines dangerous. The line passed through Duddingston, Craigmillar, Niddrie, Newcraighall and out to Dalkeith. The service was a great success, moving over 300 tons of coal a day. A passenger service, started in 1832, carried a quarter of a million people by the end of the 1830s. The line was bought by the North British Railway Company in 1845 and is now a cycle path. The engine shed is now the Holyrood Gin Distillery.

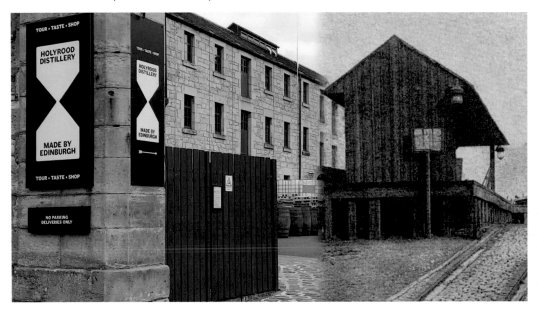

Thomas Nelson's Parkside Works, Dalkeith Road

The Baronial frontage of Thomas Nelson's Parkside Works on Dalkeith Road is shown in the older image. Thomas Nelson opened a second-hand bookshop in Edinburgh's Old Town in 1798. In 1845, Nelson's established a printing house at Hope Park – this building burnt down in 1878 and by 1880 the business had moved to the Parkside Works on Dalkeith Road. In the early part of the twentieth century, up to 400 people were employed at the Parkside Works. The development of off-set lithography in the 1950s made it cheaper to print abroad and Edinburgh's printing industry almost disappeared. In 1968, the Parkside Works were demolished to make way for the offices of the Scottish Widows Insurance Company, which have since vacated the building.

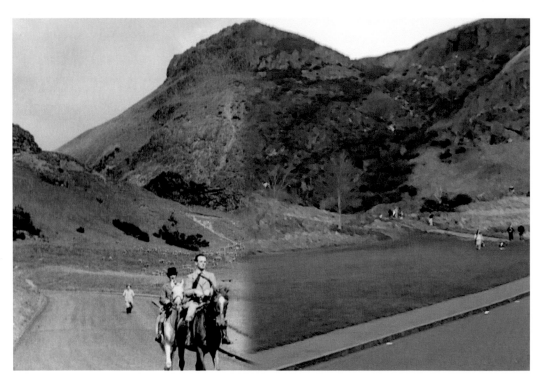

Arthur's Seat, Horse Riding
The older image shows a group horse riding in Holyrood Park with Arthur's Seat as a backdrop. A flock of sheep can also be seen in the background.

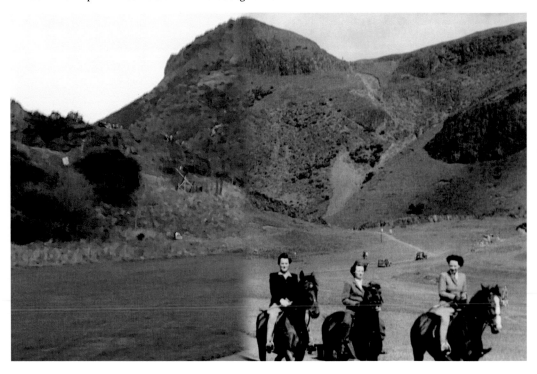

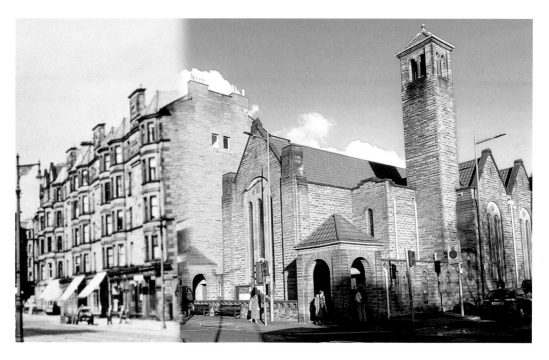

Holy Corner

Holy Corner in Morningside/Bruntsfield takes its name from the collection of churches built around the crossroads. The tramcar 180 in the older image was built by the Edinburgh Transport Department's Shrubhill Works as an experimental model in 1932. It was known as the *Red Biddy* due to the red paintwork which was different from the colour that was adopted for the fleet. *Red Biddy* was still in use when the trams were scrapped in 1956.

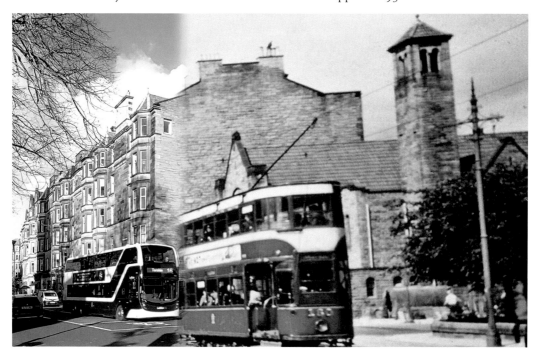

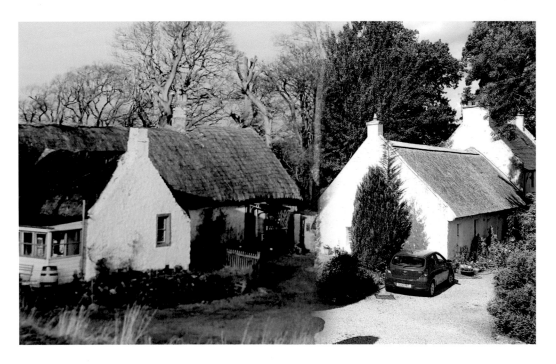

Swanston

The picturesque thatched cottages at Swanston are sited on both sides of Swanston Burn with the village green in the centre. At the end of the Second World War, the cottages were very basic with earth floors and no water and electricity. A particularly bad winter in 1947 left forty villagers cut off by huge snowdrifts. By 1954, the cottages had fallen into a state of disrepair, and those of which were habitable were used only as holiday cottages. In 1956, an ambitious scheme converted the cottages into renovated dwellings.

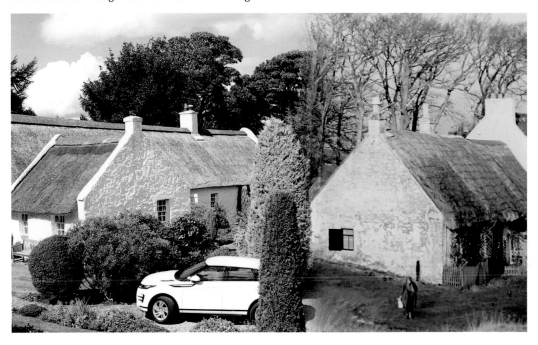

94

Also available from Amberley Publishing

ISBN 9781445698380

EDINBURGH
IN
50
BUILDINGS

JACK GILLON

ISBN 9781445661704